POSTCARD HISTORY SERIES

Williamsburg

IN VINTAGE POSTCARDS

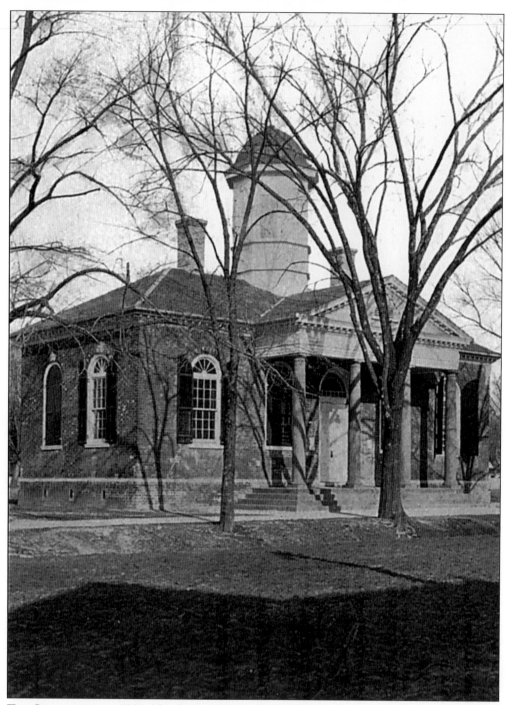

THE COURTHOUSE, C. 1911. After the fire of 1911, the Courthouse finally received the columns it had been lacking since it was built in 1770–1771. However, it would lose them again when Williamsburg was restored to its colonial appearance. Duke of Gloucester Street, seen in the foreground, was described by Rev. W.A.R. Goodwin as "99 feet wide and two feet deep" because of its unfortunate tendency to be excessively dusty in dry weather and excessively muddy when rainy.

POSTCARD HISTORY SERIES

Williamsburg

IN VINTAGE POSTCARDS

Kristopher J. Preacher

ARCADIA

Published by Arcadia Publishing,
an imprint of Tempus Publishing, Inc.
2 Cumberland Street
Charleston, SC 29401

Printed in Great Britain.

Library of Congress Catalog Card Number: 2002103966

For all general information contact Arcadia Publishing at:
Telephone 843-853-2070
Fax 843-853-0044
E-Mail sales@arcadiapublishing.com

For customer service and orders:
Toll-Free 1-888-313-2665

Visit us on the internet at http://www.arcadiapublishing.com

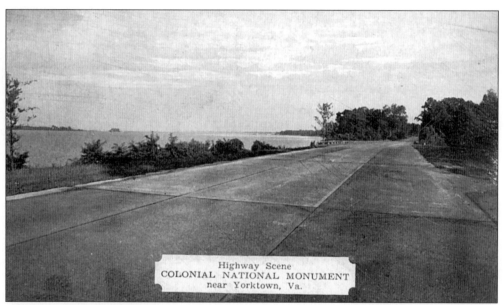

COLONIAL NATIONAL PARKWAY, C. 1938. The Colonial Parkway was part of the Colonial National Monument, an area originally intended to include Yorktown, Jamestown, and Williamsburg. The idea to hand the town over to the National Park Service after its restoration was met with considerable protest by local citizens in 1930, so Williamsburg's involvement with the project was limited to allowing the parkway to pass through town. The Colonial Parkway approaches the historic area from the northeast, passes under Courthouse Green through a 1,183-foot tunnel completed in 1942, and exits south toward Jamestown. The tunnel served as a bomb shelter during World War II. The parkway itself was finally completed in 1957 in time for Jamestown's 350th anniversary celebration.

CONTENTS

ACKNOWLEDGMENTS

A book like this is impossible to compile in isolation. I wish to thank fellow collectors Steven Beauter, H. Allen Curtis, Thomas Hearn, Kurt Reisweber, and Barry Zimmerman for the temporary loan of their postcards. I thank Terry L. Meyers, H. Allen Curtis, Thomas Hearn, Louise Lambert Kale, and Barry Zimmerman for their critical reviewing skills and untiring enthusiasm for every aspect of this project. Margaret Cook, Angela O'Sullivan, Susan Riggs, and Gina Woodward of Swem Library Special Collections went beyond the call of duty for me. Thanks also to the Colonial Williamsburg Foundation's Michael Bourne, Edward A. Chappell, Patricia Gibbs, Ronald Hurst, Carl Lounsbury, Marianne Martin, Richard Nicoll, and John R. Watson for answering my persistent questions. Any errors are mine and not theirs.

The Lake County Museum kindly granted permission to reproduce postcards originally published by the Curt Teich Company of Chicago. The College of William and Mary generously granted permission to reproduce postcards from the Carlton J. Casey Papers of the Williamsburg Historic Records Association collection. I appreciate the aid lent by Barbara C. Baganakis, Deno Baltas, Eleanor Cabell, Scott and Miriam Fitchett Middleton, Betsy Sacalis, Elizabeth Sacalis, and George F. Wright in identifying places and faces obscured by time. To Bobbie Bryant, Anne Cutler, and Evelyn Lee I extend my thanks for sharing their reminiscences and for extending hospitality to a total stranger. Thanks also go to Laura New for being a terrific editor and to Gilinda Rogers and Andy Bogursky, without whose generosity I would not have been given this opportunity. I sincerely thank Angela and Tyler Bassett for helping me prepare the final drafts and for providing moral support throughout the project. Who would have thought such a small book would be so much work? Thanks to Wil Cunningham, Greg Gudleski, and Sarah Stokes for the long walks down Duke of Gloucester Street, which I will never, ever forget.

This work is dedicated to the memory of Dr. Carlton J. Casey, whose amazing collection of postcards was generously donated to The College of William and Mary. Without his posthumous contributions, this offering would have been much less interesting. Although I never had the opportunity to meet him, I feel certain he would have enjoyed this book.

INTRODUCTION

Most visitors to Williamsburg are aware that it played a pivotal role in American history, but some general points bear repeating. Until 1699, Jamestown was the capital of colonial Virginia, but it was judged too vulnerable and unhealthy to continue as the capital of a growing colony. The decision was made to move the capital inland to a nearby community known as Middle Plantation, which already had the rudiments of a town, including scattered houses, a tavern, a church, and The College of William and Mary. The new town was christened Williamsburg for King William III of England.

Williamsburg served as the capital city of the British colony of Virginia from 1699 until 1780, the height of the American Revolution. Americans can trace the roots of their national identity to debates in the Capitol and secret meetings in the Raleigh Tavern. The College of William and Mary has been in its current location since before Williamsburg itself existed and continues today as one of the nation's top-ranked public universities. The institution founded on Francis Street in 1773 as the Public Hospital for Persons of Insane and Disordered Minds is still in operation today as Eastern State Hospital, the first mental hospital in America.

When the city's vulnerable location and unsuitability as a port obliged the government to remove to Richmond in 1780, Williamsburg's days in the limelight of history seemed numbered. With the passing of British control, Williamsburg began a slow decline into obscurity. For the next century and a half, the College and the hospital served as cornerstones of the town's otherwise agrarian economy, but poverty reigned. The former capital of Virginia was forgotten, although its "vestiges of departed grandeur" were remarked upon by many a traveler. Williamsburg's long slumber was interrupted by two wars. A Civil War battle fought just east of town was followed by three years of Union occupation, after which Williamsburg's economic prospects reached a low point. The city experienced prosperity again during World War I when a munitions factory was built in nearby Penniman, but the short-lived economic boom evaporated when the fighting was over, leaving in its wake several cheaply built encroachments on formerly open village greens.

Williamsburg residents have always been both conscious and protective of the priceless heirlooms bequeathed to them by history. The Association for the Preservation of Virginia Antiquities (APVA) had been founded in Williamsburg in 1889 expressly to preserve threatened historic structures first in Williamsburg and later in other parts of the commonwealth. But the APVA did not have limitless capital. By the 1920s Williamsburg was a shabby, bucolic southern town with little in the way of commerce. Colonial houses and other historic structures were falling into quiet ruin while cheaply constructed businesses rose on the old foundations. There was no dearth of patriotic sentiment; rather, ancient homes and businesses were crumbling for want of funds to pay for their upkeep. Ironically, the fact that so many colonial structures survived to the present can be attributed to the same lack of money, for it was often less expensive to renovate than to demolish and build anew.

It was the dream of Rev. W.A.R. Goodwin, the rector of Bruton Parish Church, to secure funds to preserve what was left of the town's colonial structures and rebuild what had disappeared. Goodwin saw Williamsburg as a diamond in the rough—hidden behind false storefronts, tin roofs, and Victorian porches lay the remnants of a glorious past waiting to be revealed. Largely as a result of Goodwin's charisma and passion for preservation, John D. Rockefeller Jr. became interested in financing the preservation of at least part of the city. Rockefeller was cautious at first, but in the end he committed vast sums of money to the preservation of existing colonial structures, as well as the full restoration of the city to its colonial splendor. This was accomplished through the establishment of Colonial Williamsburg, Inc. in 1928 and the Williamsburg Holding Corporation, which in 1934 was renamed Williamsburg

Restoration, Inc. These two entities merged in 1970 to form the Colonial Williamsburg Foundation. Between 1926 and 1928, properties had been quietly bought by Rockefeller through Goodwin, one by one, until much of the town secretly belonged to the corporation. At a town meeting in June 1928, the purchaser's identity was revealed, as were his plans for the town's rebirth.

Thus it was that in the years immediately following 1928, Williamsburg changed abruptly from a sleepy backwater town into a tourist mecca. The coming of "the Restoration" was a mixed blessing. Many jobs were created, and an otherwise stagnant town was revitalized. However, in order to recreate an authentic colonial atmosphere, many 19th century buildings were destroyed before their time. The character of Williamsburg was completely changed in the course of this destruction and restoration. The familiar town was abruptly thrown backwards in time 150 years. No longer did the city's economy depend primarily on jobs generated by the College, the hospital, and farming—tourism quickly became the main source of income. Hotels, restaurants, and guest homes thrived on the new economy and the city expanded to keep pace with the influx of tourist dollars. Tourism remains Williamsburg's primary source of revenue. In addition to Colonial Williamsburg, the city is now home to Busch Gardens-Williamsburg, Water Country USA, The Williamsburg Pottery, outlet malls, golf courses, and a host of small tourist attractions, all of which ultimately owe their success to the Restoration.

It is with a strong sense of nostalgia that older local residents remember a time without Colonial Williamsburg—when motorists could fill their gas tanks on Duke of Gloucester Street, children went to school on the Palace Green, and cattle grazed in yards. For good or ill, that part of Williamsburg is gone now. The Williamsburg that existed before the Restoration is preserved in the distant memory of a few, as well as in old photographs, books, oral histories—and, as you will see, in postcards.

Williamsburg enjoyed a small tourist industry soon after the railroad first came through town in 1881. The 1907 Jamestown Exposition in Norfolk drew many tourists to the nearby town. Williamsburg photographers like J. Paris Goodbar and James H. Stone capitalized on the demand for souvenir postcards beginning around this time, recording scenes which would prove valuable to future historians. Publishers like Louis Kaufmann in the 1910s and H.D. Cole in the 1920s and 1930s would continue to supply travelers with keepsake photographs. In time, Colonial Williamsburg would dominate the local postcard market by retaining publishers such as The Albertype Company of Brooklyn, Curt Teich of Chicago, and H. Vontobel of Switzerland, among others. All of these printers and many others are represented on postcards in these pages.

This book includes postcards printed approximately between 1902 and the early 1950s. Buildings frequently change names over the years, but each building's most recent designation is provided first in the caption title, even if it contradicts information printed on the postcards themselves. In these cases past names are always noted in the text. Every effort has been made to ensure that the information provided is correct, although errors are inevitable. Dates included in the captions are sometimes known, but are often educated guesses drawing upon several sources of information, including contemporary texts, postmarks, publisher information, serial numbers, details in the photographs, and the like. Information on the postcards themselves, particularly the early ones, is often incorrect. In these cases it is safer to trust information in the caption rather than what is printed on the postcard.

An earlier volume on Williamsburg stated that "a new book on Williamsburg should have something new to offer" (Chamberlain, 1947). I wholeheartedly agree with this sentiment. The information in the captions accompanying these images may not be new to you, but most of the illustrations probably are. If the chapters of this book share a unifying theme, it is that someone, somewhere, thought these postcards were worth sending to friends and loved ones. To that extent, these postcards have something important to say about the times that produced them. What this book offers, then, is the opportunity to see Williamsburg through the eyes of past generations. I hope you draw as much enjoyment from seeing these wonderful images as I have had gathering, researching, and sharing them. I hope the images in this book will give the reader a sense of how much things in Williamsburg have changed, and stayed the same, in the last 300 years.

One
THE HOMES
OF WILLIAMSBURG

Visitors to Williamsburg are struck by the abundance, beauty, and practical simplicity of the colonial homes peppering the town. Most houses in what is now the historic area were made of wood rather than brick, which was more expensive and thought to encourage dampness. The modern visitor might be surprised to learn that Williamsburg was almost bare of shade trees in the 18th century. By the middle of the 18th century, many houses were painted white, partly to reflect the summer heat. Many kitchens were built free-standing to avoid odors, unwanted heat, and the risk of fire. For many, the ubiquitous white weatherboarding and dormer windows represent an era when everything, even architecture, was simpler.

 One of the key features of Williamsburg that made it a good candidate for wholesale restoration was the number of colonial structures that had remained intact despite wars, neglect, fires, and the inexorable destructiveness of early 20th-century progress. Most of the 88 original buildings were homes, many of them still well-maintained and inhabited by descendants of their colonial occupants. The fact that so many original structures survived is likely due to the removal of Virginia's government—and therefore much of Williamsburg's economic activity—to Richmond in 1780. With no money to build modern structures, it was often cheaper to simply maintain the old structures and add to what was already there. When the Williamsburg Holding Corporation began purchasing and restoring original buildings, it did so with an eye toward authenticity. Great emphasis was placed on preserving original materials when possible, and on historically accurate re-creation when preservation was not an option. The result of this meticulous attention to detail was a restored colonial city that not only looks authentic, but in many cases is authentic.

 Restoring and reconstructing colonial homes was only a starting point. The idea that led to the creation of Colonial Williamsburg, shared by Rev. W.A.R. Goodwin and John D. Rockefeller Jr., was that the town should be reconstructed and preserved so that future generations could be inspired by the unselfish and patriotic ideals of the founding fathers. However, early in the Restoration it was realized that few people would want to visit a dry and static reconstruction. Something was needed to breathe life into the newly restored city. Thus, efforts were undertaken toward making Colonial Williamsburg a "living museum." A colonial crafts program was initiated in 1936. Later, some colonial homes were used to house visitors. Today, more than two dozen restored or reconstructed buildings are used as guest houses, and others are rented to Colonial Williamsburg employees.

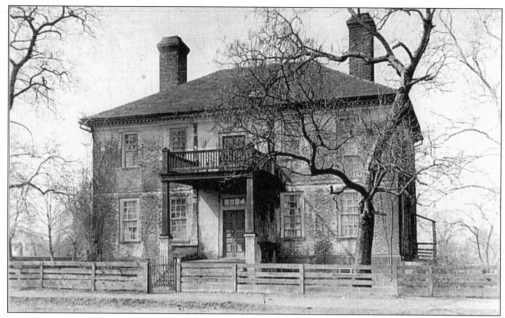

THE GEORGE WYTHE HOUSE, C. 1907. Built *c*. 1752–1755, the Wythe House was occupied by Gen. George Washington in September 1781, while the siege of Yorktown was planned. The balconied porch was removed during renovation in 1926. The house was acquired by the Colonial Dames of America and used as the parish house for Bruton Parish Church from 1927 to 1938, when Colonial Williamsburg purchased it. The house is named for early resident George Wythe, mentor to Thomas Jefferson and signer of the Declaration of Independence.

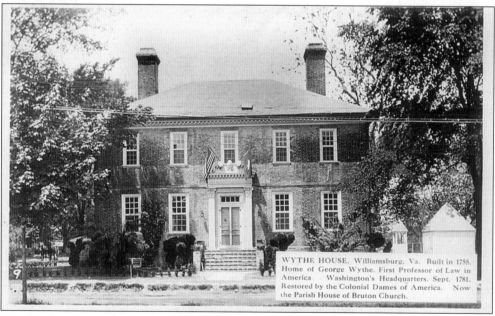

WYTHE HOUSE, Williamsburg, Va. Built in 1755, Home of George Wythe, First Professor of Law in America. Washington's Headquarters, Sept. 1781. Restored by the Colonial Dames of America. Now the Parish House of Bruton Church.

THE GEORGE WYTHE HOUSE, C. 1930. The decorations surrounding the door were added by Rev. W.A.R. Goodwin during the 1926 renovation but removed in a subsequent renovation in 1939–1940. The Wythe House opened as an exhibition building in March 1940.

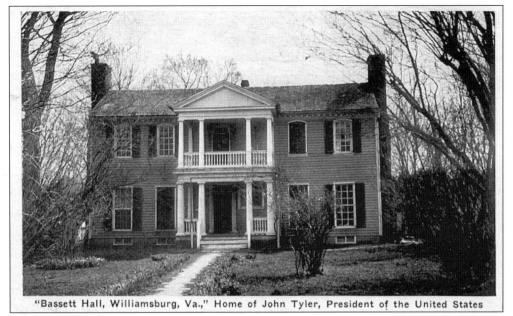

"Bassett Hall, Williamsburg, Va.," Home of John Tyler, President of the United States

BASSETT HALL, C. 1928. Bassett Hall, pictured here not long before its 1928–1930 restoration, was originally built sometime between 1753 and 1766 at the east end of Francis Street by Col. Philip Johnson. It was named for early resident Burwell Bassett, a nephew of Martha Washington. George Armstrong Custer served as the best man at a wedding ceremony, which took place in the house in 1862.

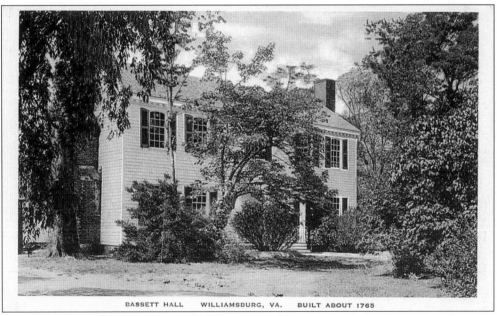

BASSETT HALL WILLIAMSBURG, VA. BUILT ABOUT 1765

BASSETT HALL, C. 1936. Restoration began in 1928. The 19th-century porch was removed and replaced with a more colonial-styled one. In May 1930, the home was damaged by fire but saved from total destruction by Williamsburg's new fire engine, a gift from John D. Rockefeller Jr. Today Bassett Hall is best known as having been Mr. and Mrs. Rockefeller's Williamsburg home during and after the Restoration; they stayed here two months out of every year. It remained in their family until 1980.

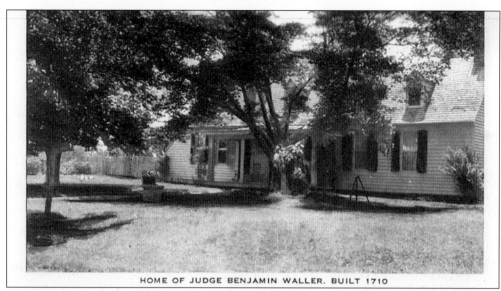

HOME OF JUDGE BENJAMIN WALLER, BUILT 1710

THE BENJAMIN WALLER HOUSE, C. 1930. The Benjamin Waller House is located at the junction of Waller and Francis Streets, near the entrance to Bassett Hall. The eastern (left) portion of the house is the oldest, perhaps predating 1750. Benjamin Waller was an attorney and a teacher of George Wythe, and he held numerous civic titles. The house passed through several succeeding generations of Wallers. In the early 20th century it was the home of the popular Morecock sisters (Pinkie, Agnes, Kitty, and Patty), who became fast friends with their neighbors in Bassett Hall, the Rockefellers. The Morecocks sold their home to the Restoration in 1941 under a life tenancy agreement, and the home was restored in 1951.

THE PEYTON RANDOLPH HOUSE, C. 1938. Located on the corner of North England and Nicholson Streets, this was home to Peyton Randolph, Speaker of the Virginia House of Burgesses and president of the first Continental Congress. It consists of a large central portion dating to *c.* 1755, which joined two earlier structures together. The eastern portion, probably built *c.* 1717, was reconstructed in 1939–1940. Lafayette and Rochambeau headquartered here before the siege of Yorktown. Lafayette returned to stay here on his 1824 tour of the country that he helped liberate. Painted white for as long as anyone can remember, it is now painted a rusty red in accordance with its supposed colonial color scheme.

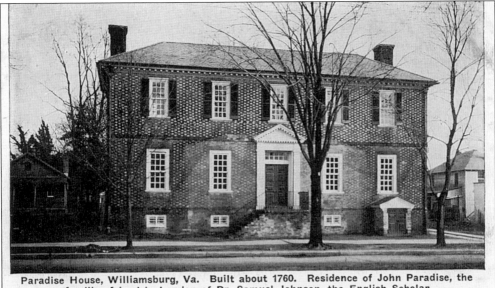

Paradise House, Williamsburg, Va. Built about 1760. Residence of John Paradise, the familiar friend in London of Dr. Samuel Johnson, the English Scholar.

THE LUDWELL-PARADISE HOUSE, C. 1929. The Ludwell-Paradise House, built *c.* 1752, was named for early residents. Until the 1920s it boasted a large Victorian porch, the outlines of which can be seen in this postcard. The porch was replaced by a decorative portico and steps, seen here. The Restoration unofficially began in 1926 with the purchase of this house, although it was the last to be restored under Rockefeller's original plan. It was known simply as the Paradise House until the early 1930s. The houses visible on either side were likely built in the 1920s and were demolished when the city was restored.

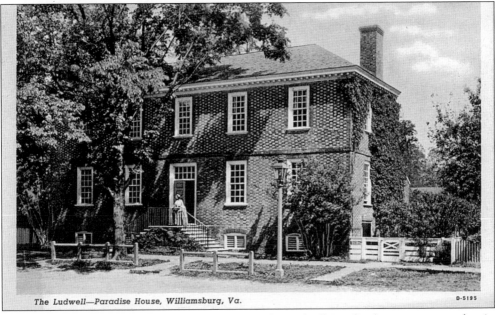

The Ludwell—Paradise House, Williamsburg, Va. D-5195

THE LUDWELL-PARADISE HOUSE, C. 1937. In 1931, the Ludwell-Paradise house was restored to its colonial appearance—with a simpler entranceway, the exterior basement entrance on the building's east (right) side, and a double set of entrance steps instead of a single flight. It contained a library for a while before restoration and later housed Abby Aldrich Rockefeller's collection of American folk art.

13

Beautiful Providence Hall now Open for Guests — Telephone: 1135-J OC-H1

PROVIDENCE HALL, C. 1950. Providence Hall was built west of Williamsburg in Providence Forge sometime during the 18th century. Because it lay in the path of progress, in 1947 it was purchased at auction by Virginia B. Haughwout, completely dismantled, and moved from Providence Forge to Williamsburg to save it from destruction. Now situated on a hill just southeast of the Williamsburg Inn at the end of Bucktrout Lane, Providence Hall was opened as a guest house in 1950. The odd-shaped porch has been replaced with one more faithful to the colonial original. The house is currently on lease to Colonial Williamsburg by the Bucktrout-Braithwaite Memorial Foundation and is operated as a guest house and conference facility.

THE ST. GEORGE TUCKER HOUSE, *C.* 1910.
The St. George Tucker House began life *c.*
1718 as a one-story house facing Palace
Green. The original structure was later
moved and rotated to face Market Square. It
was enlarged and additions were built
between 1788 and 1790. The house was
restored in 1930–1931. The extension on the
west (left) was reconstructed on original
foundations using some of the original
surviving frame. One of this home's many
claims to fame is that it was the home of St.
George Tucker, a law professor at William
and Mary, noted patriot, and man of many
literary talents. Several of Tucker's
descendants also entered the legal profession.

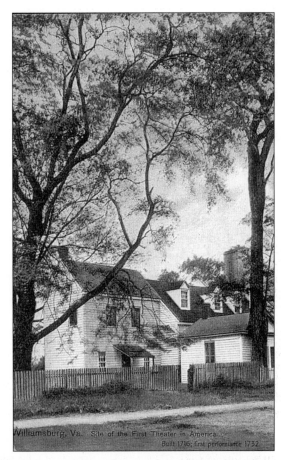

THE ST. GEORGE TUCKER HOUSE, *C.* 1911.
One of the first documented Christmas trees
in eastern Virginia was put up in 1842 in the
St. George Tucker House by the Rev. Dr.
Charles F.E. Minnegerode, a houseguest of
Nathaniel Beverley Tucker. The house was
home to descendants of St. George Tucker
until 1993. Now it is used as a guest
reception center for donors to the Colonial
Williamsburg Foundation.

Williamsburg, Va. Site of the First Theater in America.
Built 1716; first performance 1732.

Old Home of Edmund Randolph,
Williamsburg, Va.

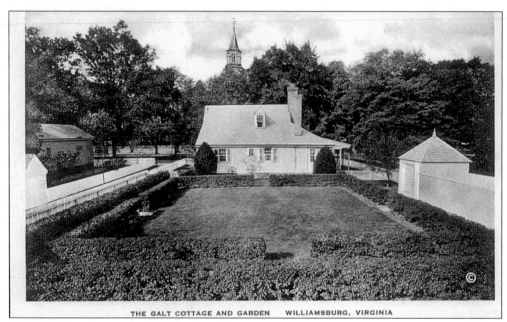

THE GALT COTTAGE, C. LATE 1930S. The Galt Cottage was originally built on the grounds of Eastern State Hospital by James Galt, the hospital's first superintendent, and was later inhabited by his son, William Trebell Galt. It was moved to its temporary home across Duke of Gloucester Street from Bruton Parish Church in 1929, shown here. The cottage was moved to Tyler Street, south of the historic area, in 1954. The lot above has since been restored as a garden area.

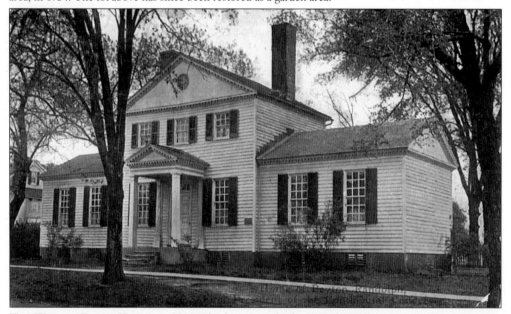

THE WILLIAM FINNIE HOUSE, C. 1911. This house was built *c.* 1776 by William Finnie, a quartermaster general in the Revolutionary War, and may have been designed by Thomas Jefferson. It was known for years as the Semple House after William and Mary law professor and judge James Semple, who bought the house in 1800. The William Finnie House was long thought—incorrectly—to have been the home of Peyton Randolph. The William Finnie House was restored in 1932, but required no major changes.

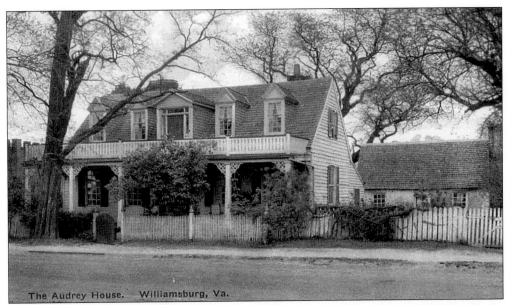

The Audrey House. Williamsburg, Va.

THE BRUSH-EVERARD HOUSE, *C.* LATE 1920S. Located on the east side of Palace Green, the Brush-Everard House was built by John Brush *c.* 1718, making it one of the oldest houses in Williamsburg. The kitchen behind the house is original. Said to have been Gov. John Page's townhouse, it was popularly known as the "Audrey House" in the early 20th century because Mary Johnston featured it in her 1902 novel *Audrey*. One windowpane is scratched with the enigmatic note, "J.B., 1796, Nov. 23—O fatal day."

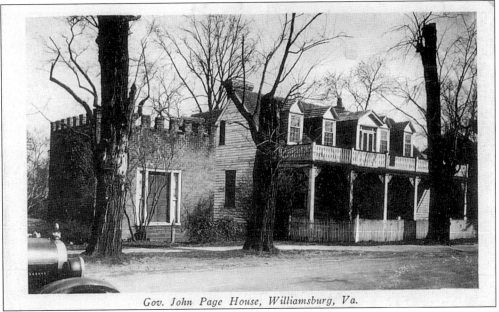

Gov. John Page House, Williamsburg, Va.

THE BRUSH-EVERARD HOUSE, *C.* 1930. The Brush-Everard House has also been known as the Brush House and the Gov. John Page House. Misses Estelle and Cora Smith operated it as a boarding house in the early 20th century—they preferred to call it the Smith House. The 19th-century porch, brick law office, and second-story door were removed during renovation in 1949–1951, after which the restored house was opened to the public.

17

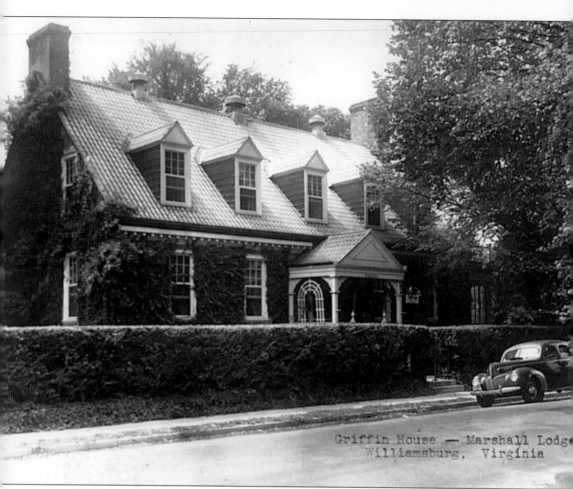

Griffin House — Marshall Lodge
Williamsburg, Virginia

THE GRIFFIN HOUSE/WILLIAM BYRD III HOUSE, C. 1940s. This building, long known as the Griffin House or Marshall Lodge, is located on Francis Street between South Boundary Street and South Henry Street. It was probably built *c.* 1770 but was never restored to its colonial appearance. Recent evidence has come to light that it was owned by William Byrd III of Westover. It was the home of Congressman Samuel Griffin until 1810 and later was the home of the Marshall family. Bruton Parish Church received the home by bequest and sold it to the Restoration. The Pi Kappa Alpha fraternity (Gamma chapter) moved in during the fall of 1939. It housed Colonial Williamsburg's merchandising offices starting *c.* 1975 but now contains the local offices of Legg Mason.

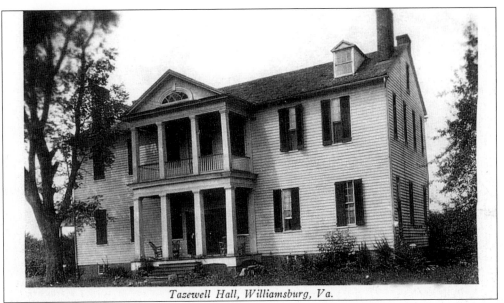

Tazewell Hall, Williamsburg, Va.

TAZEWELL HALL, *C.* **1930.** Tazewell Hall was built *c.* 1765 at what was once the southern end of South England Street, facing north, by John "the Tory" Randolph. One wing and a second floor were added in 1836 by Littleton Tazewell. In 1906 it was moved 25 yards to the west and rotated to face the street. By the time of the Restoration, the house was occupied by Peyton Randolph Nelson, an eccentric soul who lived a spartan life and grazed his cattle on public greens. Nelson took full advantage of the life tenancy arrangement offered by Colonial Williamsburg, letting "little repairs grow into large ones." The house fell into alarming disrepair. After Nelson entered a nursing home, the house was dismantled and reconstructed as a private residence on Riverside Drive in Newport News, where it stands today.

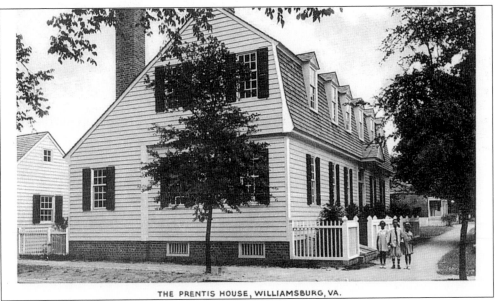

THE PRENTIS HOUSE, WILLIAMSBURG, VA.

THE PRENTIS HOUSE, *C.* **1941.** The reconstructed Prentis House was built on remarkably intact original foundations and is located on the northeast corner of Botetourt and Duke of Gloucester Streets. The original house was likely built between 1712 and 1714 by John Brooke, father-in-law of William Prentis.

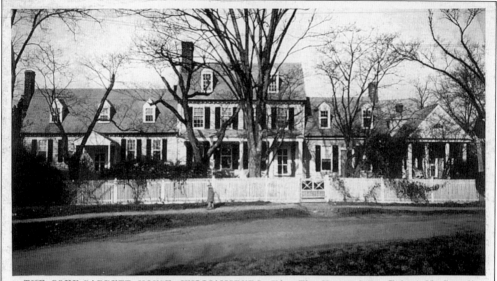

THE COKE-GARRETT HOUSE, WILLIAMSBURG, VA. The Home of Dr. Robert M. Garrett and Family. One of the Most Beautiful Places in Williamsburg. Building and Gardens Restored by Mr. Rockefeller. This House Was Owned for Many Years by the Coke Family. Near the Capitol.

THE COKE-GARRETT HOUSE, *C.* 1929. Only the eastern and western portions of this house, located at the eastern extremity of Nicholson Street, are colonial in origin. The western wing existed by 1755 and the central section was built in 1836–1837. The entire house was retained by the Restoration despite the youth of the central section because it was built in a style consistent with colonial architecture. The central section regained its missing middle dormer during restoration but lost its Victorian porch.

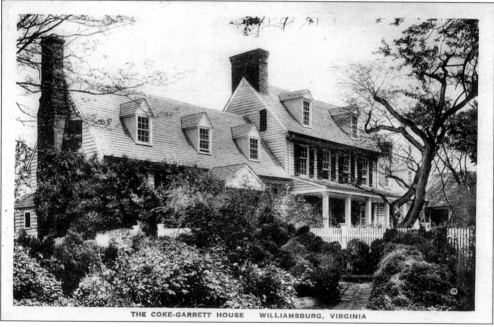

THE COKE-GARRETT HOUSE WILLIAMSBURG, VIRGINIA

THE COKE-GARRETT HOUSE, *C.* 1936. The Garrett family lived here from soon after the Revolution until the home was sold to the Restoration. The Coke-Garrett House has been the residence of the president of Colonial Williamsburg since the 1970s.

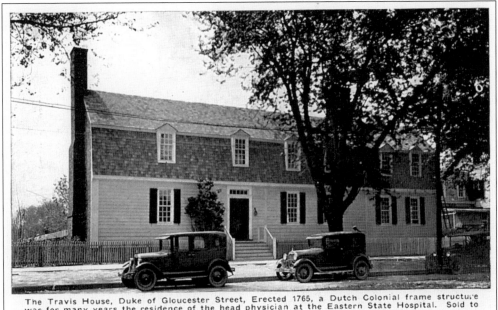

The Travis House, Duke of Gloucester Street, Erected 1765, a Dutch Colonial frame structure was for many years the residence of the head physician at the Eastern State Hospital. Sold to the restoration and moved to it's present location on Duke of Gloucester Street.

THE TRAVIS HOUSE, C. 1930. The Travis House consists of three sections, the first of which was built *c.* 1765 by Col. Edward Champion Travis. It once sat on the property of Eastern State Hospital on the northeast corner of Francis and South Henry Streets but was moved in 1929 to Duke of Gloucester Street across from Bruton Parish Church.

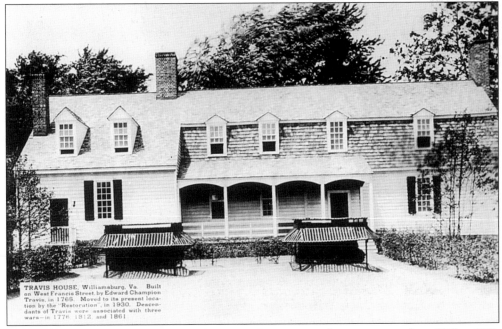

TRAVIS HOUSE, Williamsburg, Va. Built on West Francis Street, by Edward Champion Travis, in 1765. Moved to its present location by the "Restoration", in 1930. Descendants of Travis were associated with three wars—in 1776, 1812, and 1861.

THE TRAVIS HOUSE, C. EARLY 1930S. The Travis House was used as a restaurant from 1930 to 1951. Moved a second time in 1951 across the street from its colonial location, it served as the Jamestown Festival headquarters in 1957. There it sat until 1968, when it was returned to its original location.

21

The Custis House. Williamsburg, Va.

THE ROBERT CARTER HOUSE, C. 1907. This house, facing Palace Green just southwest of the Governor's Palace, was probably built in the 1740s. It belonged to Robert Carter III during the Revolution. The house has also been known as the Page House, the Saunders House, the Carter-Saunders House, and the Dinwiddie-Saunders House at various points in its history. Robert Saunders Jr. was president of William and Mary from 1846 to 1848, and Robert Dinwiddie was lieutenant governor of Virginia from 1751 to 1757. The house was ransacked (but mercifully not burned) by Union soldiers in 1862. Despite the caption on this postcard and the one below, a Custis never lived there. (From the Carlton Casey collection, Swem Library, College of William and Mary.)

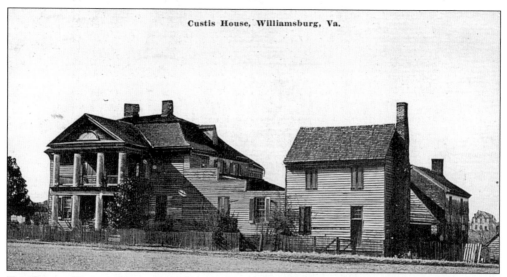

Custis House, Williamsburg, Va.

THE ROBERT CARTER HOUSE, C. 1930. One room of the Saunders House was used as a school for girls starting in 1873. The house was restored in 1931–1932 and again in 1951–1953. During restoration, a brick drive was uncovered in front of the house. The massive porch was removed and replaced with a much simpler one of colonial design. The Robert Carter House was used as an early office for the Williamsburg Holding Corporation.

22

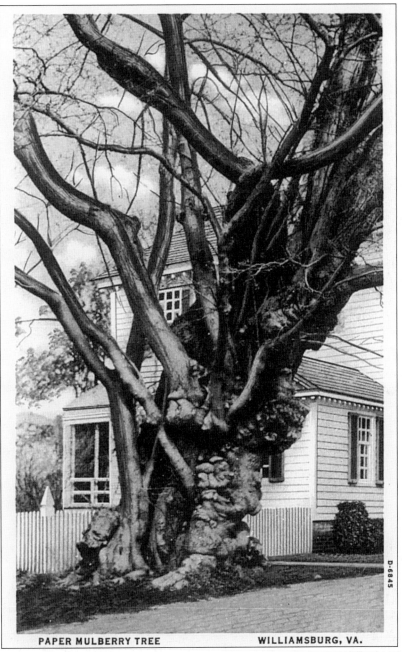

PAPER MULBERRY TREE WILLIAMSBURG, VA.

Paper Mulberry Tree at the Robert Carter House, c. 1942. Several specimens of paper mulberry can still be seen in the historic area of Williamsburg, though none are quite so impressive as this one was. True mulberries were once commonly planted in Virginia in an unsuccessful attempt to establish a local silk industry—silkworms eat the leaves of white and black mulberry. The paper mulberry is a member of a different genus and is not a good candidate for silk production but has typically been used as an ornamental tree in North America since its introduction, *c.* 1735. The first paper ever produced was made by Chinese craftsmen nearly 2,000 years ago from the bark of the paper mulberry, hence the tree's name.

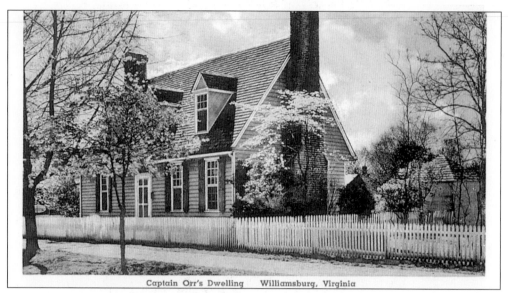

Captain Orr's Dwelling Williamsburg, Virginia

THE GEORGE REID HOUSE/CAPTAIN ORR'S DWELLING, C. LATE 1930S. This house, on the southwest corner of Duke of Gloucester and Colonial Streets, has been known variously as the Deneufville House, the Barlow House, and the Barradall-Barlow House after families who have lived in it. Until at least 1949, it was called Captain Orr's Dwelling, so named after a blacksmith who occupied a previous house on the lot. It is now named for George Reid, the merchant and militiaman who built it between 1789 and 1792. In the 1920s, Miss Emma Lou Barlow lived here.

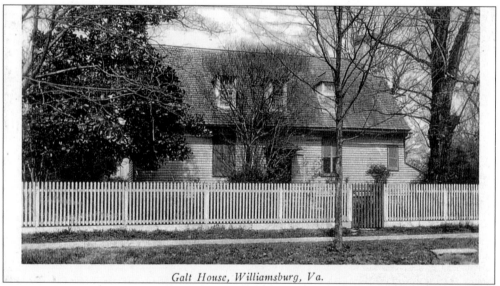

Galt House, Williamsburg, Va.

THE NELSON-GALT HOUSE, C. 1929. The Nelson-Galt House is located on Francis Street, southwest of the Capitol. It was once thought to have been built *c.* 1676 and to have been the home of Otho Thorpe, where Nathaniel Bacon's followers swore allegiance to him. The General Assembly of Virginia was also said to have met here in 1677. Recent research shows it to have been built *c.* 1695 elsewhere, moved to its present location early in the 18th century, and expanded. The Nelson-Galt House was owned by the Nelsons of Yorktown during the Revolution; in the early 19th century it passed into the hands of the Galt family, five generations of which acted as superintendents of Eastern State Hospital.

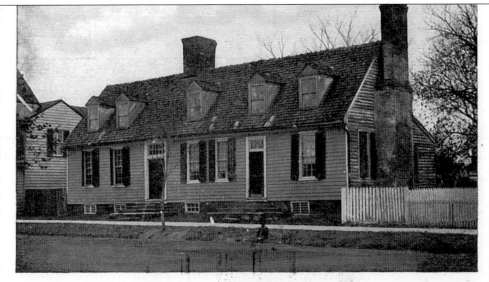

Home of John Blair, Williamsburg, Va.

THE JOHN BLAIR HOUSE, C. 1906. One of the oldest and best-preserved houses in Williamsburg, this house is named for John Blair Sr., twice governor of the Virginia colony and nephew of Rev. James Blair, founder and first president of The College of William and Mary. His son, John Blair Jr., was appointed a Supreme Court justice by Washington. John Marshall, first chief justice of the Supreme Court, also lived here. During the Civil War, the basement served as a bakery for Union troops and the occupied Fort Magruder east of town. The building on the left was a dry goods store and millinery.

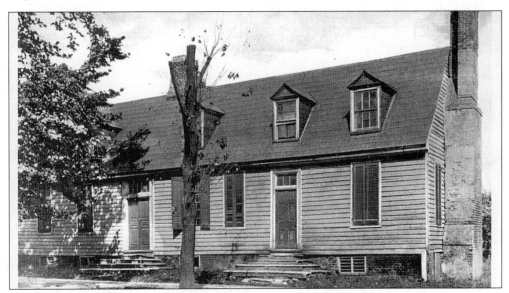

THE JOHN BLAIR HOUSE, C. LATE 1920s. The eastern portion of the house is the oldest, having been built *c.* 1722. Local legend says the stone steps may have been brought from the site of the first theatre in America (on Palace Green), accounting for the "First Theatre" caption commonly seen on postcards featuring the house. It was used as a kindergarten, a dancing school, and, during the 1920s, the Pi Beta Phi sorority house. Rev. W.A.R. Goodwin eventually purchased the Blair House to save it from being razed and replaced with a garage. Restoration to its colonial appearance required only minimal changes.

25

THE GEORGE PITT HOUSE, *C.* 1944. The George Pitt House was reconstructed on the northeast corner of Colonial and Duke of Gloucester Streets, the site of the original house built *c.* 1718. It is notable for its atypical basement kitchen. During the 18th century, it was the home of Christopher de Greffenried, Sarah Packe (who used it as a millinery shop), and George Pitt, who opened an apothecary shop at "The Sign of the Rhinoceros" behind the house. John Dixon, a printer, bought the house in 1774.

Pitt-Dixon House · Williamsburg, Virginia

RESTORATION HOUSE, *C.* 1929. Built in 1846 or 1847 across the street from Bruton Parish Church, this was the church rectory until 1927. In that year it was renovated and used to house Restoration officials. Materials from the demolished building were used in the construction of other area buildings. (From the Carlton Casey collection, Swem Library, College of William and Mary.)

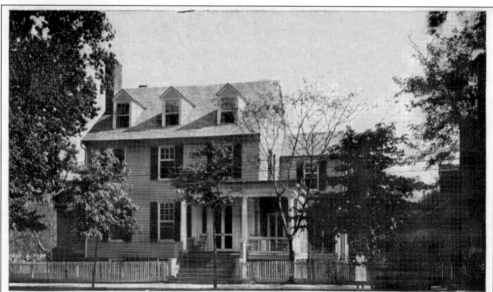

Restoration House, opposite Bruton Church, occupied by Mr. John D. Rockefeller, Jr. and family when visiting Williamsburg, formerly the Rectory of Bruton Church, and now owned by the Restoration. Built in 1846.

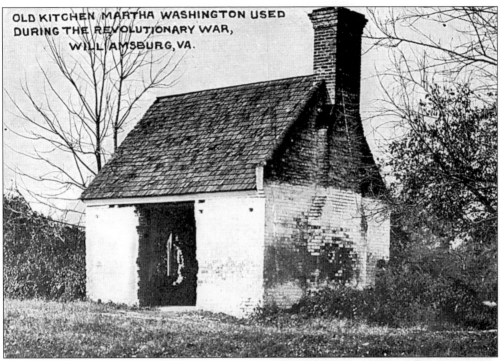

OLD KITCHEN MARTHA WASHINGTON USED DURING THE REVOLUTIONARY WAR, WILLIAMSBURG, VA.

THE CUSTIS KITCHEN, POSTCARD C. 1913. The Custis Kitchen is located on the "Six Chimney Lot" portion of the former Eastern State Hospital grounds. This lonely building is all that remains of the once magnificent estate of Col. John Custis on Francis Street. The Custis estate was inherited by the colonel's son, Daniel Parke Custis, in 1749. After Daniel's death, it was managed by his widow Martha until 1778—she later married George Washington and the couple lived at the estate for a time. This photograph postcard dates at least as far back as 1906.

HOSTESSES AT THE GOVERNOR'S PALACE, C. 1940S. The crown jewel of Colonial Williamsburg is unquestionably the Governor's Palace, a meticulous reconstruction of the home of the royally appointed governors of the Virginia colony. The Governor's Palace, so called because an exorbitant amount of taxpayers' money was spent in its construction, was begun *c.* 1707 by master builder Henry Cary, but it languished for lack of funds. It was completed years later during Alexander Spotswood's tenure as governor. The Palace housed seven royal governors before the Revolution and governors Patrick Henry and Thomas Jefferson during it.

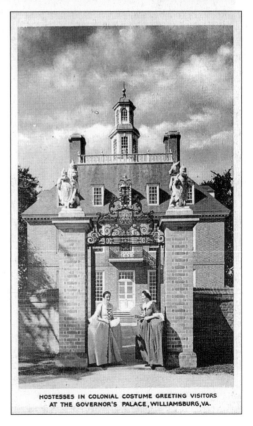

HOSTESSES IN COLONIAL COSTUME GREETING VISITORS AT THE GOVERNOR'S PALACE, WILLIAMSBURG, VA.

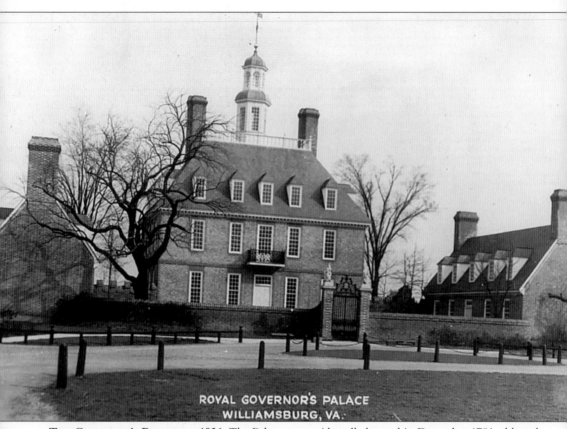

ROYAL GOVERNOR'S PALACE
WILLIAMSBURG, VA.

THE GOVERNOR'S PALACE, C. 1936. The Palace was accidentally burned in December 1781, although its two advance buildings survived as homes well into the 19th century. They were completely dismantled during the Civil War so that their bricks could be used for officers' huts at Fort Magruder. The Governor's Palace was rebuilt between 1931 and 1934. Remaining foundations, written accounts, a copperplate image, and floor plans drawn by Thomas Jefferson were instrumental in the reconstruction. Interior furnishings are based on a detailed inventory made after the death of Governor Botetourt. The reconstructed advance buildings of the Palace include a guard house (left) and the Governor's Office (right). Because of its grandeur and the attention to detail necessary to reconstruct it, the Governor's Palace has rightly been called "the crowning achievement of the Williamsburg Restoration."

Two

THE COLLEGE OF

WILLIAM AND MARY

In 1691, Virginia's General Assembly dispatched Rev. James Blair to England to petition for the establishment of a college in Virginia. An earlier attempt to found such an institution in the colony had been abandoned after a 1622 Native American uprising and the revocation of the Virginia Company charter in 1624. By the 1690s, however, native populations did not pose as much of a threat to colonists in eastern Virginia as they once had, and sons of Virginia planters needed a proper education without having to travel to Massachusetts or England to get it. The time was ripe.

A charter was granted, a location was chosen, and in 1695, construction was begun. Classes were in session in the new brick building by 1700. The location was Middle Plantation, an agricultural settlement already boasting relatively high, fertile ground, a few homes, and an Anglican church. The presence of the College was a contributing factor in the decision to move the capital of the Virginia colony away from swampy Jamestown to higher ground. Williamsburg was officially established in Middle Plantation in 1699, with The College of William and Mary at the western end of its new central avenue, Duke of Gloucester Street. Other buildings soon arose. The Brafferton was erected in 1723 to house a Native American school in accordance with the charter. The President's House was constructed a decade later facing the Brafferton across the College Yard, rendering the campus pleasingly symmetric.

William and Mary remained more or less the same size for 200 years, but that was to change. The declining years of the 19th century saw an expansion of campus across Jamestown Road. The new century saw two periods of even greater expansion. The first occurred in the 1920s under the direction of Pres. J.A.C. Chandler, during whose administration several dormitories and new classroom buildings were erected. The second occurred in the 1960s under Pres. Davis Y. Paschall, during whose tenure the western portion of campus was greatly expanded. William and Mary became a state institution in 1906 and formally became a university in 1968, but proudly retains the word "college" in its name. Enrollment ballooned from only a handful of students at the turn of the 20th century to about 1,500 students by 1930. Today William and Mary covers 1,200 acres and has a yearly enrollment of over 7,500.

Among North American institutions of higher learning, The College of William and Mary is second only to Harvard in age. Since its establishment, William and Mary has survived several fires, two wars involving enemy occupation, unimaginable financial hardship, and a seven-year stretch without any students. It saw the establishment of the Phi Beta Kappa Society, the collegiate fraternity system, and the honor code. In the 20th century, William and Mary witnessed coeducation, racial integration, two World Wars, and the restoration of Williamsburg to its colonial appearance. Over the centuries it has produced three presidents, as well as numerous other influential politicians, writers, thespians, theologians, entrepreneurs, and scientists who have left their marks on history. It is not without reason that The College of William and Mary was called "The Alma Mater of a Nation" by President Paschall.

Bird's Eye View W. & M. College, Williamsburg, Va.

PUB. BY J. H. STONE

THE COLLEGE OF WILLIAM AND MARY, C. 1906. Here, from left to right, are the Wren Building, the President's House, and the Brafferton. Until 1902, the College was actually outside the city, which until that year stopped, aptly enough, at Boundary Street. The boundary was in name only, as students and townsfolk mingled freely and knew each other well.

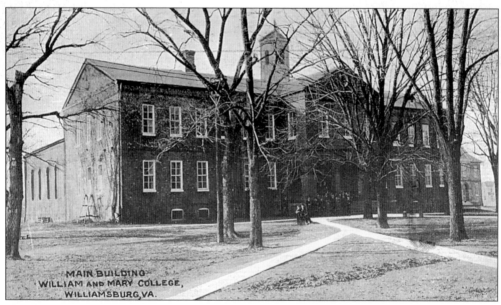

MAIN BUILDING
WILLIAM AND MARY COLLEGE,
WILLIAMSBURG, VA.

THE WREN BUILDING, C. 1913. William and Mary's main building and most enduring symbol was constructed in 1695. Its interior was destroyed by fire in 1705, in 1859, and again in 1862. Always, after each reconstruction, the exterior walls were incorporated into the new structure. Because of this, the Wren Building can rightly be called the oldest academic building in the United States, Harvard having failed to preserve her edifices with as much enthusiasm. Since the early days of the Restoration it has been known as the Wren Building after Sir Christopher Wren, its supposed designer.

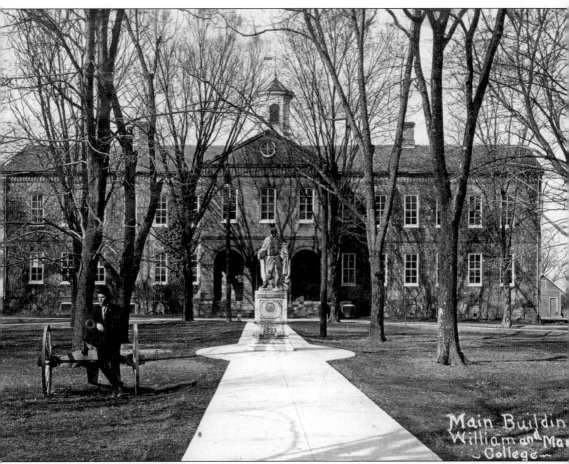

Main Building
William and Mary
—College—

THE WREN BUILDING, C. 1907. On the left is "Ol' Spotswood," the cannon donated to the College by faculty and local citizens on February 19, 1901. The cannon had been taken from Fort Christanna, Gov. Alexander Spotswood's 1713 outpost on the Meherrin River. The functional cannon was a favorite tool for campus pranksters, so we can hardly blame college president Lyon G. Tyler for having its muzzle permanently plugged by a blacksmith in 1907. The structure behind the Wren Building to the right was a wood shed. (From the Carlton Casey collection, Swem Library, College of William and Mary.)

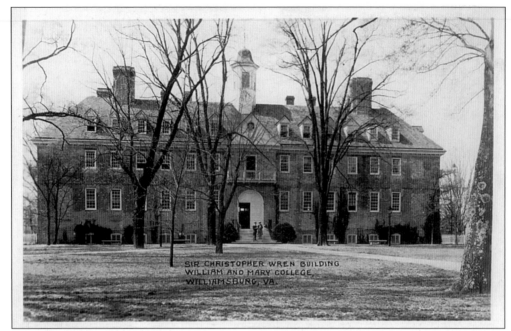

THE WREN BUILDING, C. 1930S. The Wren Building was last burned in 1862 by Union troops in retaliation for a Confederate cavalry raid. It is said that Union troops prevented historically minded townspeople from trying to extinguish the blaze. Thereafter its ruined shell was used as a military storehouse, and the historic structure was eventually rebuilt by 1869. Steps were taken to fireproof the Wren Building during its 1929 renovation.

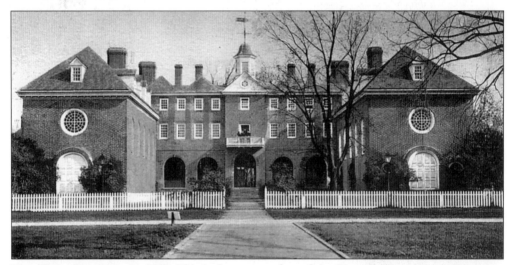

THE WREN BUILDING, C. 1937. This is the western face of the Wren Building. The building was originally intended to form a quadrangle. There is evidence that some foundations were laid, but the fourth side was never built. Reconstruction of the irregular west roof was greatly informed by an engraved copperplate discovered in the Bodleian Library in 1929. On the left (north) is the Great Hall. On the right (south) is the Chapel, built in 1732 to mirror the Great Hall. Close examination of the exterior brickwork of the Chapel and Great Hall reveals the slightly lower and slanted roofline worn by the building from 1859 to 1929.

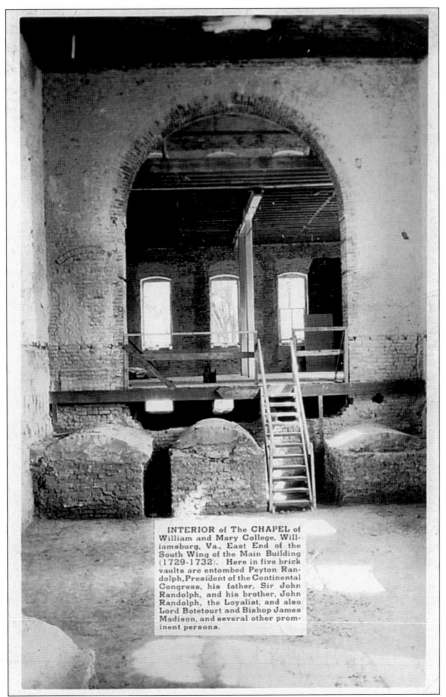

INTERIOR of The CHAPEL of William and Mary College, Williamsburg, Va., East End of the South Wing of the Main Building (1729-1732). Here in five brick vaults are entombed Peyton Randolph, President of the Continental Congress, his father, Sir John Randolph, and his brother, John Randolph, the Loyalist, and also Lord Botetourt and Bishop James Madison, and several other prominent persons.

THE WREN BUILDING CHAPEL CRYPT, C. 1929. During the 1929 renovation of the Wren Building, the flooring was taken up, exposing as many as 12 tombs beneath. The crypt was looted by Union soldiers in 1862, and efforts to positively identify tenants of the vaults since then have been largely unsuccessful. Still, it is nearly certain that Lord Botetourt, John Randolph and his sons Peyton and John, and two William and Mary presidents—Bishop James Madison and Thomas Dew—are among the interred.

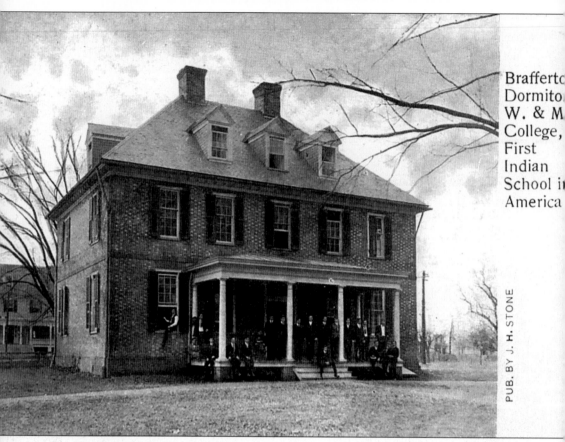

Braffertc
Dormito
W. & M
College,
First
Indian
School i
America

PUB. BY J. H. STONE

THE BRAFFERTON, C. 1906. The Brafferton forms the southern side of the College Yard. It was probably built by Henry Cary Jr., but history does not record this as a certainty. Its original intent was to house a school for Native Americans, which it did until around 1776. The Brafferton was named for a Yorkshire estate purchased by the executors of Robert Boyle; income from the estate was used to erect the structure and fund the school. The Brafferton was used as the headquarters for Union officers after the Battle of Williamsburg in 1862. It served as a dormitory in the late 19th and early 20th centuries, and the people sitting and standing on the porch were likely students housed there. The porch, recently enlarged in this photograph, was removed altogether during the building's restoration in 1931–1932. It now houses the offices of the President and the Provost of the College.

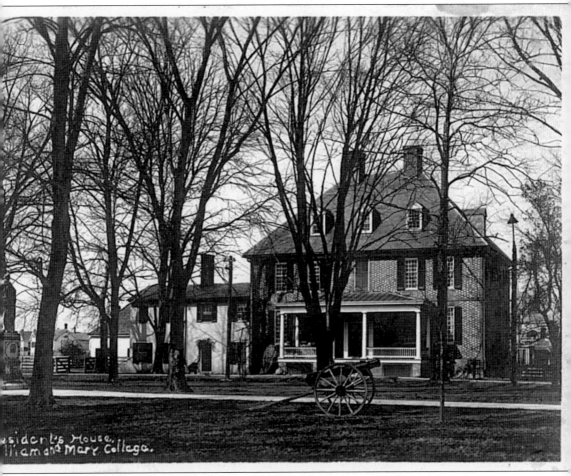

THE PRESIDENT'S HOUSE, C. 1907. Built in 1732–1733 by Henry Cary Jr. to face the Brafferton across the College Yard, the President's House is larger than the Brafferton by four feet in each dimension. All but one of the college's presidents have lived in this house. In June 1781, Williamsburg was easily captured by the British army and General Cornwallis used the house as his headquarters. In October the building was burned while being used as a hospital for French officers wounded at Yorktown, leaving the walls intact. Repair costs were quickly provided from the French treasury. Attached to the western (left) side of the President's House in this postcard is the extension built in 1865 to house faculty members after the Wren Building burned for a third time. The extension was removed *c.* 1920. Just visible west of the western extension is the garage, built as a stable in the 19th century and still standing. The porch, originally added in 1849, was widened to encompass two first-floor windows sometime between 1903 and 1907 and removed altogether when the building was restored to its colonial appearance in 1931.

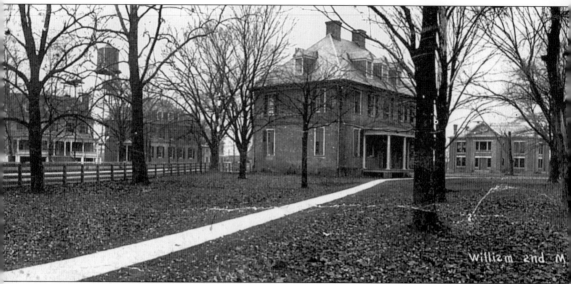

THE COLLEGE OF WILLIAM AND MARY, C. 1907 (ABOVE) AND C. 1909 (BELOW). These postcards are twice the typical width. Beginning at the extreme left and continuing to the right, are Ewell Hall (formerly the College Hotel), Taliaferro Hall, and the college infirmary, all across Jamestown Road from the main campus. Other prominent structures, from left to right, are The Brafferton, the gymnasium, the Main Building (later the Wren Building), the science building (later the second Ewell Hall), and the President's House. In 1922, the gymnasium was converted to classroom use and renamed Citizenship Hall. It was demolished in 1931. Taliaferro Hall and the infirmary were built *c.* 1894. Taliaferro began life as a dormitory, but was renovated in 1937 to house the fine arts department.

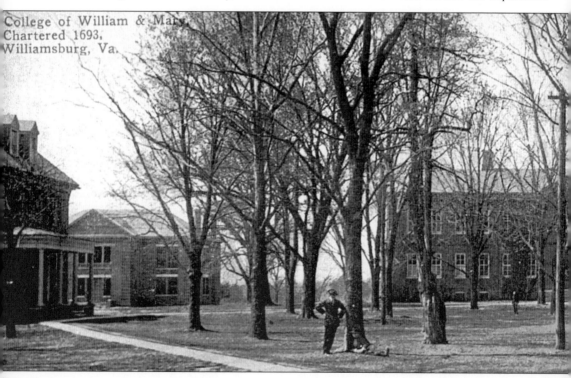

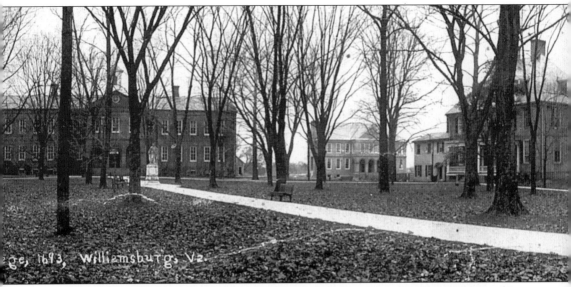

For a while it served in both capacities. It was demolished in 1967. The College Hotel was built in 1852. In 1859 it was purchased by the College and served as a dormitory to house students displaced by the fire, which gutted the Main Building. It continued to be used as a dormitory until it was torn down in 1927. In 1894 The College Hotel was renamed and became the first of three campus buildings to bear the name Ewell Hall. The postcard below shows a scene similar to the one above, five years later. An addition to the scene is the College Library (later much expanded and named Tucker Hall), built in 1908 and visible in the distance between the Wren Building and the science building.

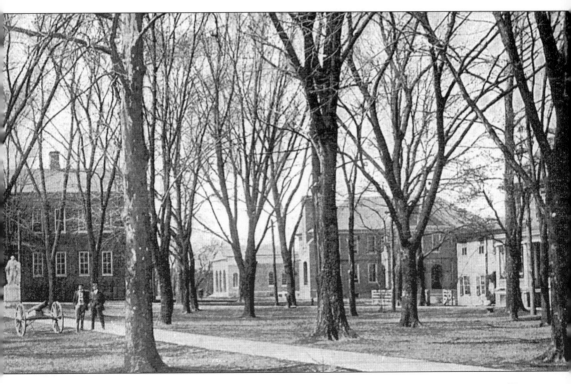

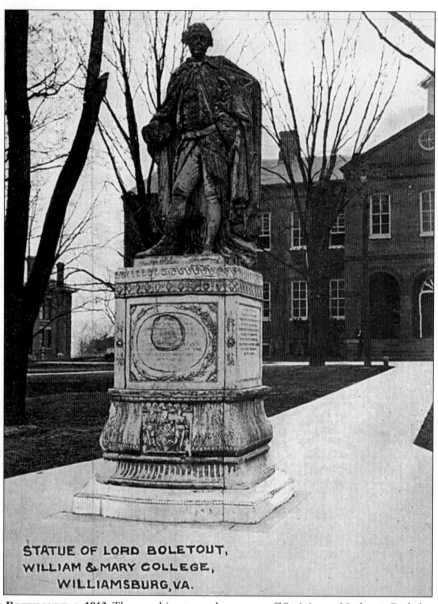

STATUE OF LORD BOLETOUT,
WILLIAM & MARY COLLEGE,
WILLIAMSBURG, VA.

LORD BOTETOURT, *C.* 1913. The penultimate royal governor of Virginia was Norborne Berkeley, Baron de Botetourt. This marble statue was fashioned by English sculptor Richard Hayward and delivered to the Capitol in 1773, three years after Botetourt's death. The statue once stood in the piazza of the Capitol at the eastern end of Duke of Gloucester Street, where it was toppled and beheaded sometime after the Revolutionary War. The defaced statue was purchased by the College in 1801 and moved to the College Yard. It was removed to Eastern State Hospital for safekeeping during the Civil War in 1864 but was returned to campus in 1874. In 1958, the statue was removed to storage. In 1965, it was placed in the basement of Swem Library (then under construction) to protect it from further damage. A bronze replica now sits in its place in front of the Wren Building. Every Christmas, the Baron celebrates the season by holding a wreath around his right arm. When passing Lord Botetourt, it was once customary to bow, curtsy, or tip one's hat to his lordship; this custom died out with the removal of the original statue to storage in 1958.

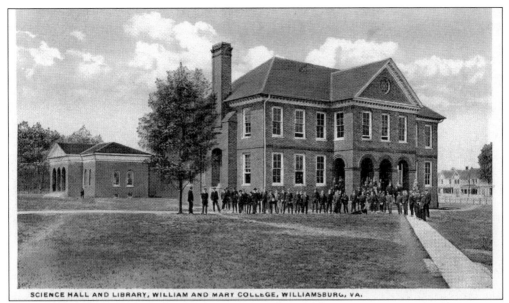

SCIENCE HALL AND LIBRARY, WILLIAM AND MARY COLLEGE, WILLIAMSBURG, VA.

SCIENCE HALL/EWELL HALL, C. 1916. Erected in 1905–1906 as a science classroom building, in 1927 this structure was dubbed Ewell Hall, the second campus building to bear that name. To the left is the College Library, now Tucker Hall. Ewell Hall was demolished in 1932. (From the Carlton Casey collection, Swem Library, College of William and Mary.)

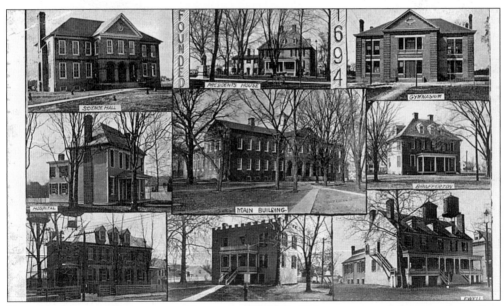

THE COLLEGE OF WILLIAM AND MARY, C. 1906–1908. This rare postcard features nine college buildings, with the Wren Building in the center. Clockwise from the top left, they are the Science Hall (later Ewell), the President's House with its 1865 wing, the gymnasium (later Citizenship Hall), The Brafferton, Ewell Hall (the College Hotel), the Steward's House, Taliaferro Hall, and the college infirmary. The last four were located across Jamestown Road from the main campus. The Steward's House was known variously as the Long House, the Rear Dormitory, and the Deanery. Around 1930 it was demolished and replaced with a fish pond.

39

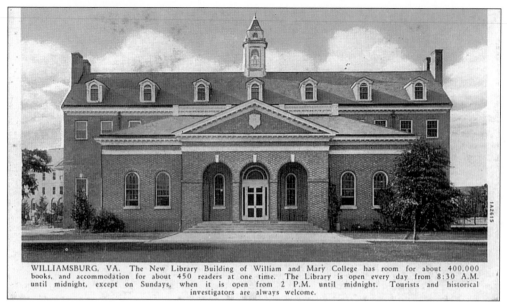

WILLIAMSBURG, VA. The New Library Building of William and Mary College has room for about 400,000 books, and accommodation for about 450 readers at one time. The Library is open every day from 8:30 A.M. until midnight, except on Sundays, when it is open from 2 P.M. until midnight. Tourists and historical investigators are always welcome.

TUCKER HALL, C. 1931. William and Mary's new library (now Tucker Hall) was built with funds donated by The Carnegie Corporation. The cornerstone, laid on April 18, 1908, contains copies of the *Virginia Gazette* and *Richmond Times Dispatch*, Lyon G. Tyler's 1907 book *Williamsburg, The Old Colonial Capital,* college bulletins, photographs, and college and Masonic papers. Virginia's governor, Claude A. Swanson, was in attendance. Monroe Hall, a dormitory, can be seen beyond the library to the left.

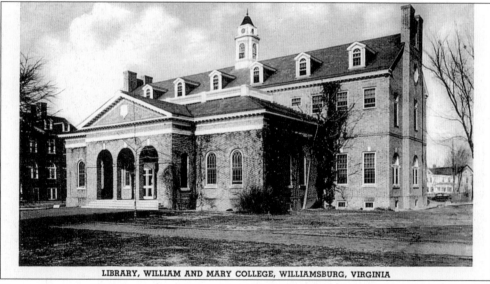

LIBRARY, WILLIAM AND MARY COLLEGE, WILLIAMSBURG, VIRGINIA

TUCKER HALL, C. 1939. Known for decades as the College Library, Tucker Hall was originally only the smaller portion on the southern face, seen here. In 1922, an addition was built onto the northern side, and in 1929, the two wings were bridged by the three-story structure seen here behind the original library. The building housed the Marshall-Wythe Law School from 1968 to 1980. Renamed St. George Tucker Hall in 1980, it now houses the English Department and the Roy R. Charles Center. On the left is Rogers Hall (now Tyler Hall). Across Richmond Road to the right is the old Methodist parsonage, built in 1909 and since razed to make room for the expansion of Williamsburg Presbyterian Church.

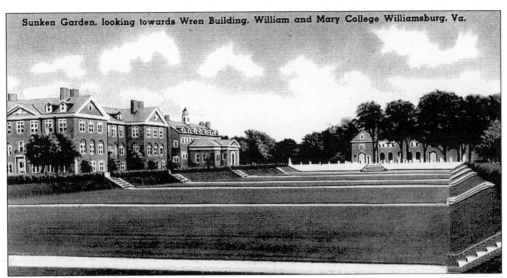

Sunken Garden, looking towards Wren Building. William and Mary College Williamsburg. Va.

THE SUNKEN GARDEN, C. 1940. The idea for the Sunken Garden was conceived by campus planner Charles M. Robinson, who had been inspired by a similar design at London's Chelsea Hospital. It was excavated in 1934–1935 as a central axis for J.A.C. Chandler's extended campus. The buildings are, from left to right, Rogers Hall (later Chancellors Hall and now Tyler Hall), the college library (now Tucker Hall), and the western face of the Wren Building. The Sunken Garden has been used for dances, sports, ROTC drills, sunbathing, and special events since its construction.

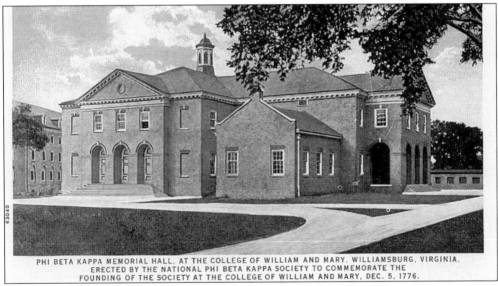

PHI BETA KAPPA MEMORIAL HALL, AT THE COLLEGE OF WILLIAM AND MARY, WILLIAMSBURG, VIRGINIA, ERECTED BY THE NATIONAL PHI BETA KAPPA SOCIETY TO COMMEMORATE THE FOUNDING OF THE SOCIETY AT THE COLLEGE OF WILLIAM AND MARY, DEC. 5, 1776.

EWELL HALL/PHI BETA KAPPA MEMORIAL HALL, C. 1927. Completed and dedicated as Phi Beta Kappa Memorial Hall in 1926, Ewell Hall now houses the Music Department and the offices of the Dean of the Faculty of Arts and Sciences, the Dean of Undergraduate Studies, and the Director of Academic Advising. Part of Jefferson Hall can be seen to the left, and to the right can be seen the temporary science building taken from the defunct munitions plant in nearby Penniman. The wing on the left (east) was destroyed by fire in December 1953 and rebuilt without the grand entrance. The small wing on the northeast corner was built to conform exactly to the dimensions of the Apollo Room of the Raleigh Tavern, where the Phi Beta Kappa Society is traditionally believed to have been founded in 1776.

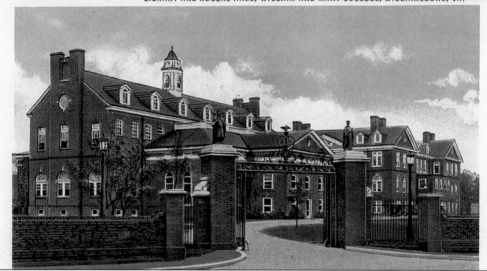

EWELL MEMORIAL GATES, *C.* 1934. Once the main entrance to the campus, Ewell Memorial Gates were named in honor of college president Benjamin S. Ewell and dedicated on June 10, 1933. The lead statues of King William III and Queen Mary II adorning the gateposts were fashioned in 1927 to honor B.B. Munford of the board of visitors. The wrought-iron gate has since disappeared. Additions to the library (now Tucker Hall) are seen on the left. Beyond it, to the right (west), is Rogers Hall (now Tyler Hall).

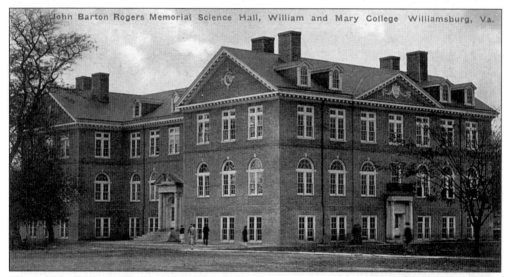

John Barton Rogers Memorial Science Hall, William and Mary College Williamsburg, Va.

TYLER HALL/ROGERS HALL, *C.* 1927–1931. William Barton Rogers Memorial Science Hall (not "John" as in the postcard) was erected in 1927 to house physics, chemistry, and psychology classrooms. Rogers, an 1828 graduate of William and Mary, founded the Massachusetts Institute of Technology in 1861. Rogers Hall was renovated in 1981–1982 to house the School of Business Administration, and it was dedicated as Chancellors Hall on February 5, 1982. In 1988, it was rededicated as Tyler Hall in honor of three generations of Tylers associated with the college. John Tyler Sr., an alumnus, served as Virginia governor from 1808 to 1811. John Tyler Jr. graduated in 1807, served as Virginia governor from 1825 to 1827, and became the 10th U.S. president in 1841. His son, Lyon G. Tyler, was a lawyer, historian, and member of the House of Delegates who served as the 18th president of the College from 1888 to 1919.

42

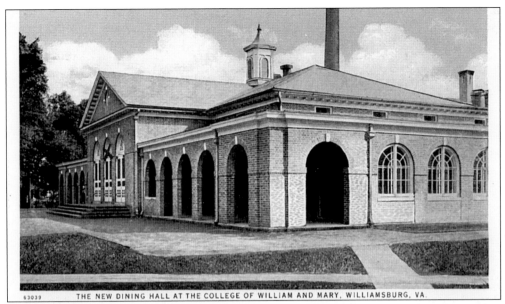

TRINKLE HALL, *C.* **1927.** The dining hall, built at the corner of Jamestown Road and South Boundary Street in 1914, was William and Mary's first free-standing dining facility. A temporary structure on the south side was damaged by a 1925 fire, and the opportunity was taken to expand the facility. It was incorporated into the new Trinkle Hall in 1925–1926. In turn, this structure was incorporated into the modern Trinkle Hall/Campus Center complex in 1984, and parts of the 1914 structure are still visible. The negative for this postcard was reversed, given the location of the smokestacks behind the building.

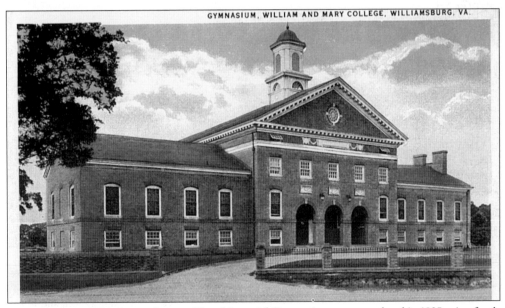

BLOW HALL, *C.* **1926.** George Preston Blow Memorial Gymnasium was completed in 1925 using funds donated by the widow of Captain Blow, a retired Navy officer with an abiding interest in Virginia history. Architect Claude Bragdon designed the exterior. Until recently, Blow Hall still had an indoor swimming pool. The building now houses William and Mary's School of Business Administration and several administrative offices. A portico has since been added to the entrance.

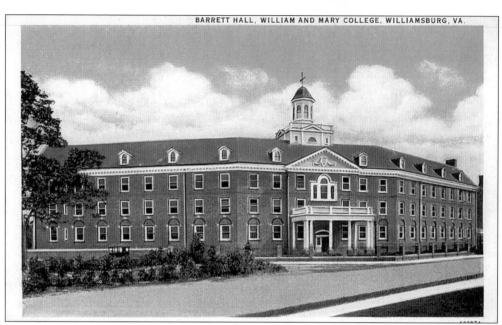

BARRETT HALL, C. 1928. Barrett Hall was built as a women's dormitory in 1927. It is named for Dr. Kate Waller Barrett, an advocate for higher education for women in the South. In 1918, William and Mary was the first state college in Virginia to become coeducational.

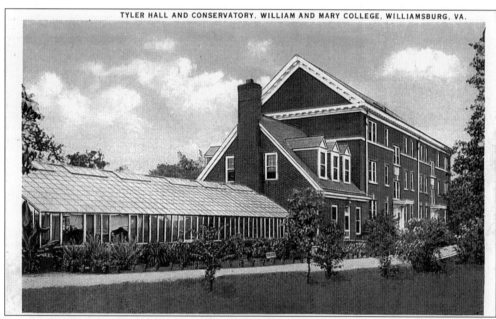

REVES CENTER/TYLER HALL DORMITORY, C. 1928. Originally a men's dormitory named for President Lyon G. Tyler, this building was erected in 1916. Only two years later this most modern dormitory on campus was used to house William and Mary's first female students, to the chagrin of many male students. The Miriam Robinson Memorial Conservatory, built onto the north side in 1926 but now gone, was used as a biology laboratory and contained a flower shop. Tyler Hall was remodeled in 1989 to become the Wendy and Emery Reves Center for International Studies.

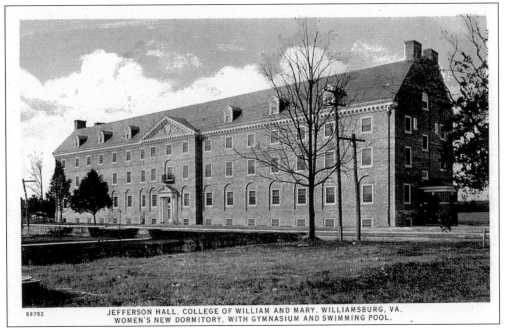

JEFFERSON HALL, COLLEGE OF WILLIAM AND MARY, WILLIAMSBURG, VA.
WOMEN'S NEW DORMITORY, WITH GYMNASIUM AND SWIMMING POOL.

JEFFERSON HALL, *C.* **1924.** Jefferson Hall, named for William and Mary student Thomas Jefferson, was built as a women's dormitory in 1921. Jefferson Hall was heavily damaged by a fire in 1983, but was repaired and reopened by January 1985. This picture was likely taken from the front lawn of the old Theta Delta Chi chapter house across Jamestown Road.

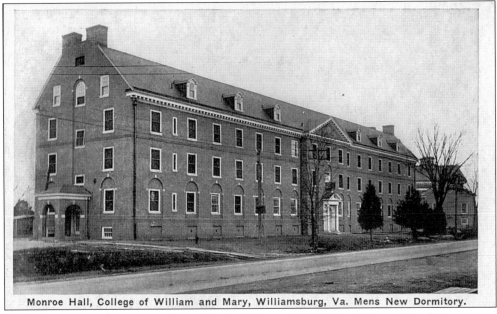

Monroe Hall, College of William and Mary, Williamsburg, Va. Mens New Dormitory.

MONROE HALL, *C.* **1930.** This is the north side of Monroe Hall, facing Richmond Road. Monroe was a men's dormitory opened in 1924 and named for President James Monroe, a William and Mary alumnus. It remained a men's dormitory until the 1970s, when it became a women's dormitory. Today it is coeducational.

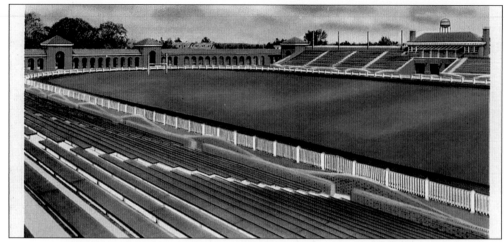

WALTER J. ZABLE STADIUM AND CARY FIELD, C. 1936. This is the "new" Cary Field; the old Cary Field was located just to the east, on the site now occupied by the Bryan Complex. Cary Field has long been the home of William and Mary's football team, the Tribe (or the Indians, until the mid-1970s). The stadium, constructed in 1934–1936, was dedicated as Zable Stadium on November 3, 1990 in recognition of a generous financial donation by alumni Walter and Betty Zable.

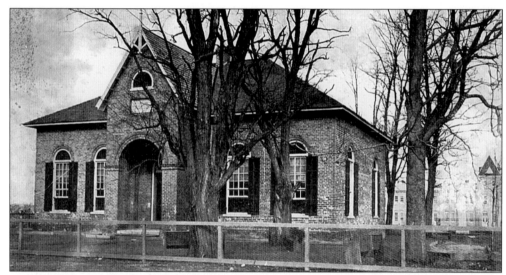

MATTHEW WHALEY MODEL AND PRACTICE SCHOOL, C. 1906. The "Matty School" was erected on the Palace Green in 1870–1871. William and Mary used funds endowed for such a purpose more than a century earlier by the bereaved mother of Matthew Whaley. Constructed in part with bricks from the ruined Governor's Palace, which had been on the site, the school originally had two rooms, but it later had four plus a principal's office. It served as a public school for white boys from 1873 to 1884 and for white boys and girls until 1894, when it became a practice school for William and Mary's teacher education program. The school was demolished in 1930 to rebuild the Governor's Palace. Visible in the background is the building that housed the Williamsburg Knitting Mill, producers of men's underwear from 1900 to 1916, and the local Virginia Electric and Power Company (VEPCO) headquarters from 1917 until the reconstruction of the Governor's Palace. Barely visible in front of the mill is a monument between 10 and 12 feet high placed by Letitia Tyler Semple in 1901 to mark the site of the Governor's Palace. This photograph was taken by local photographer James H. Stone.

Three
WILLIAMSBURG
AT WAR

Williamsburg has been associated with the military from the community's 1633 fortifications against Native Americans to the present-day training facilities, Navy shipyards, and weapons storage sites. The city's elevated location between two navigable rivers made it economical, and therefore a good location for Virginia's capital city; however, its location became a liability to colonists during the Revolution. The British captured the poorly defended city and occupied it for two days in April 1781. Lord Cornwallis occupied it again in June and 10 days later marched off to be defeated at Yorktown.

The Revolutionary War marked the beginning of Williamsburg's economic and cultural decline. Because of the war, the capital was moved to Richmond and many buildings fell into dilapidated disuse. The gardens of the Governor's Palace became a burial ground. The President's House at the College was almost completely destroyed when French soldiers recuperating there accidentally set it ablaze. With the British surrender at Yorktown in 1781, celebrations took place in the old colonial capital, but by no means did economic prosperity ensue. Williamsburg suffered from the war.

The Williamsburg area hosted American Revolution skirmishes, but nothing compared to the devastation wrought during and after the Civil War. In 1862, Union general George B. McClellan led his Army of the Potomac so slowly up the peninsula toward Richmond that he was nicknamed "the Virginia Creeper." Earlier, Confederate troops, townspeople, and slaves had dug defensive works stretching from Williamsburg to the York River in preparation for such an advance. A massive earthwork called Fort Magruder served as the centerpiece. On May 5, 1862, a battle was fought and resulted in nearly 4,000 casualties. Wounded from both sides filled Williamsburg's houses and public buildings.

The Battle of Williamsburg was a skirmish, really. In terms of the number of soldiers involved, it was reckoned the biggest battle in the Civil War, and perhaps in North America's recorded history, although it would soon be eclipsed by much larger confrontations. For the next three years Williamsburg suffered further from the indignities of enemy occupation and occasional bursts of guerilla warfare in its very streets. Evidence of the Civil War can still be seen if one knows where to look. In the woods adjoining Quarterpath Road and parts of the Colonial Parkway, the distinctive outlines of surviving Confederate redoubts can easily be discerned. Fortifications can also still be seen behind a hotel on Route 60 East, as well as on Jamestown Island. Remnants of Fort Magruder itself are preserved near Penniman Road.

Williamsburg's Courthouse Green hosted patriotic speeches and rallies during World War I. A munitions factory in nearby Penniman caused a temporary surge in Williamsburg's population and economy but increased the prices of goods and services. Camp Wallace, established in 1918 at a location now occupied by Busch Gardens and part of the Kingsmill community, was used for various military purposes until 1972. During World War II, Colonial Williamsburg hosted over 68,000 visiting military personnel. The influx of servicemen was so great that limits on their numbers had to be put in place. Today, the city is situated close to Camp Peary Armed Forces Experimental Training Activity Area, Fort Eustis Military Reservation, the United States Naval Supply Center, United States Naval Weapons Station, and the Cheatham Annex United States Naval Storage Base.

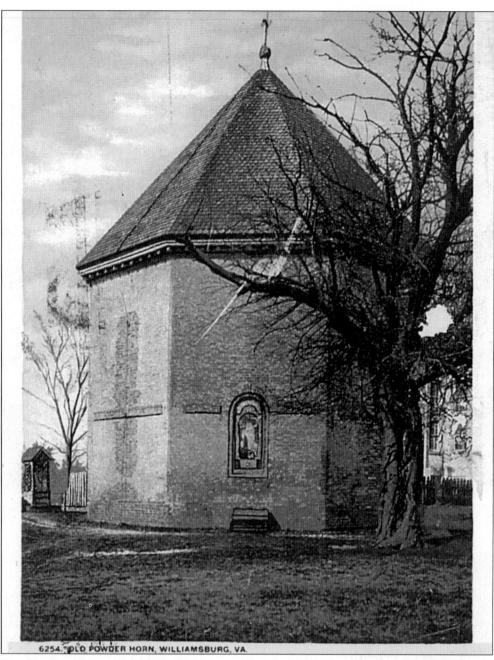

6254. OLD POWDER HORN, WILLIAMSBURG, VA.

THE POWDER MAGAZINE, *C.* 1902. The octagonal Powder Magazine was built under the direction of Gov. Alexander Spotswood in 1715 as a military arsenal. In April 1775, Lord Dunmore, the last colonial governor of Virginia, secretly had most of the guns and powder in the Magazine removed downriver to Yorktown. Dunmore paid for the material several weeks later, but too late to restore trust. Dunmore and his family fled the city in June 1775. After the Revolution, the building served as a market house; from 1833 to 1837, an African-American Baptist church; and, during the second half of the 19th century, a dance school, Confederate arsenal, and (embarrassingly) a livery stable. It was known locally as the "Powder Horn" until the Restoration.

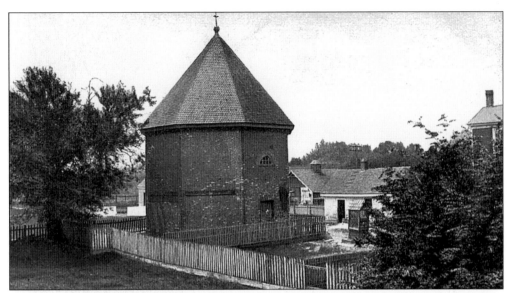

THE POWDER MAGAZINE, C. 1908. In 1888, while the Magazine was being used as a stable, one of the walls collapsed. What was left of the building was rapidly deteriorating when it was bought by the APVA in 1889 for $400. The roof burned that year but was repaired. The APVA restored the Magazine, installed stained glass windows (one of Nathaniel Bacon and one of Governor Spotswood), and opened the building as a museum. Admission was 10¢. It displayed, among other things, relics from the Raleigh Tavern, a globe from a Governor's Palace gatepost, and antique weaponry. The "Bacon window" can today be seen at Bacon's Castle in Surry County.

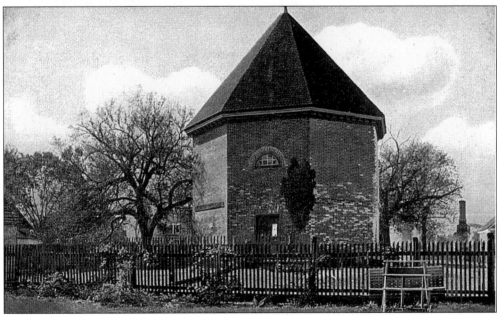

THE POWDER MAGAZINE, C. 1910. In cooperation with the APVA, Colonial Williamsburg restored the magazine in 1935 and opened it as an exhibition building on July 4, 1949. The APVA sold the Powder Magazine to Colonial Williamsburg in 1986 for $750,000. The chimney in the background on the right has since been incorporated into the reconstructed Nicholas-Tyler Office.

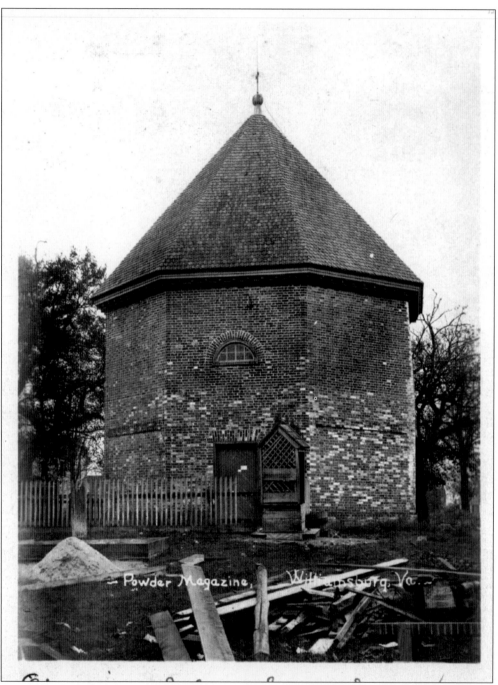

Powder Magazine, Williamsburg, Va.

THE POWDER MAGAZINE, C. 1906. The pump house near the door of the Powder Magazine had disappeared by 1910, but the pump remained for some time. The wall surrounding the magazine, which had been destroyed and used in the foundations of the neighboring Williamsburg Baptist Church, was rebuilt by the Restoration in 1934–1935. The Magazine, along with the reconstructed guardhouse to its southeast, was reopened in 1949 as an exhibition building. (From the Carlton Casey collection, Swem Library, College of William and Mary.)

50

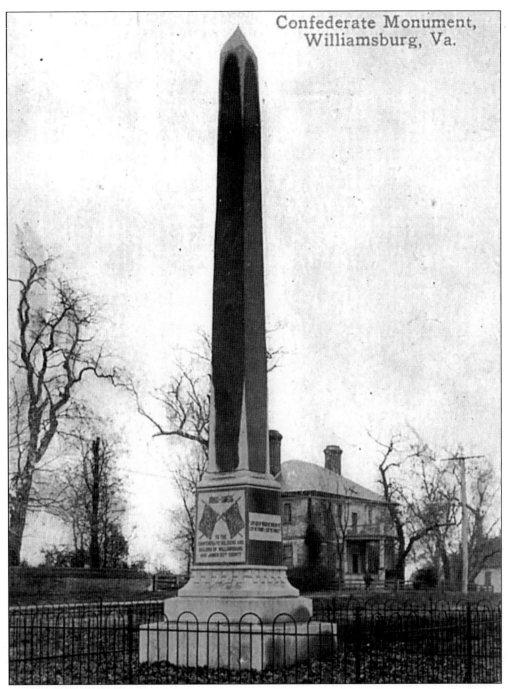

Confederate Monument,
Williamsburg, Va.

CONFEDERATE MONUMENT, C. 1911. This monument was erected on Palace Green by the United Daughters of the Confederacy on May 5, 1908. Controversy surrounded its removal in January 1932 to Cedar Grove Cemetery for four months, where it lay in pieces. The monument was not colonial enough to stay where it was, but some residents objected on the grounds that removal of a Confederate monument was unlawful. In the end, it was moved. In the background of this postcard are the George Wythe House (right) and the wall surrounding Bruton Parish Church (left).

51

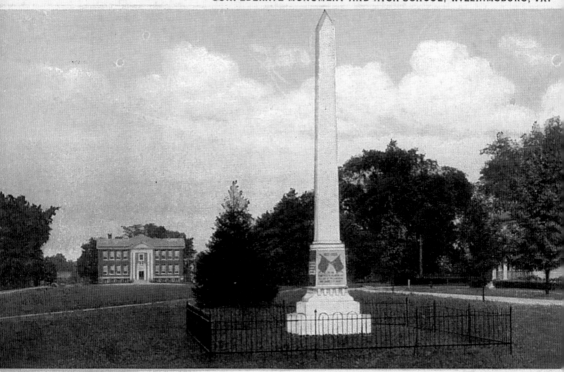

1112C

THE CONFEDERATE MONUMENT, C. 1926. Behind the Confederate Monument is Williamsburg High School, built in 1921 and demolished in 1933. The choice to build the school on the historic Palace Green was met with dismay by local members of the APVA. The Confederate Monument found its third home beside the new James City County Courthouse on South England Street in 1932 after much legal wrangling but was moved again in 1969 to the grounds of the new courthouse on Court Street. In 2000 it was moved yet again when the courthouse was abandoned. It now stands in Bicentennial Park on Court Street, adjacent to the Galt family cemetery.

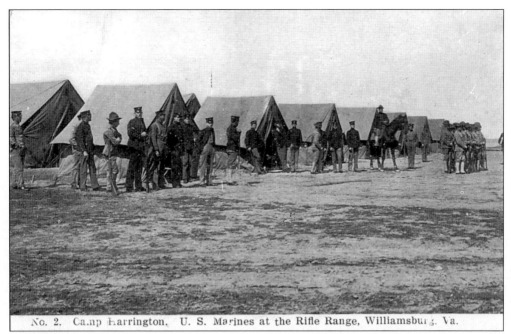

No. 2. Camp Harrington. U. S. Marines at the Rifle Range, Williamsburg, Va.

CAMP HARRINGTON, C. 1909. Camp Admiral Harrington was established in July 1905 as a rifle range for the United States Marine Corps. The range was located on the southern bank of the York River, just west of where Queens Creek joins it, on land now occupied by Camp Peary.

No. 5. Camp of the U. S. Marine Corps Rifle Team at Williamsburg, Va.

CAMP HARRINGTON, C. 1909. "Williamsburg Wins Ballgame: In a hotly contested (hot because it was so) game of base ball last Saturday afternoon on Court Green between the Williamsburg and Camp Admiral Harrington nines, the local team won an easy victory from the soldiers. The score stood 7 to 14. There was a big crowd of rooters on hand."—*The Virginia Gazette*, July 21, 1906.

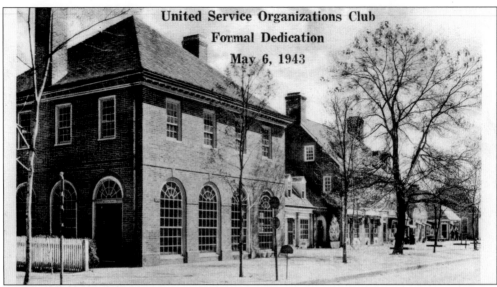

UNITED SERVICE ORGANIZATION, C. 1939. The Stringfellow Building (left) housed a Howard Johnson's restaurant from the 1950s to the 1970s. Today it is Binns Fashion Shop. During World War II, this building served as Williamsburg's primary U.S.O. It was enlarged and reopened in 1943 by the Rockefellers. During the war, because of Williamsburg's historical significance and proximity to several military installations, thousands of soldiers and sailors from nearby bases were required to spend a day in Williamsburg to gain a greater appreciation for the country they were defending, all expenses paid by the Rockefellers. Many military personnel also gained a great appreciation for the ABC store across the street from the U.S.O. (From the Carlton Casey collection, Swem Library, College of William and Mary.)

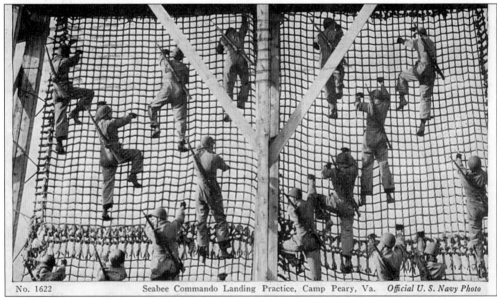

CAMP PEARY, C. 1943. In 1942, Camp Peary was established on a 4,500-acre tract on the York River north of Williamsburg. Its area was to double the next year. Camp Peary was founded as a Seabee (Naval Construction Battalion) training facility. In 1944 it became the United States Navy Training and Distribution Center, and in 1945 it began housing prisoners of war.

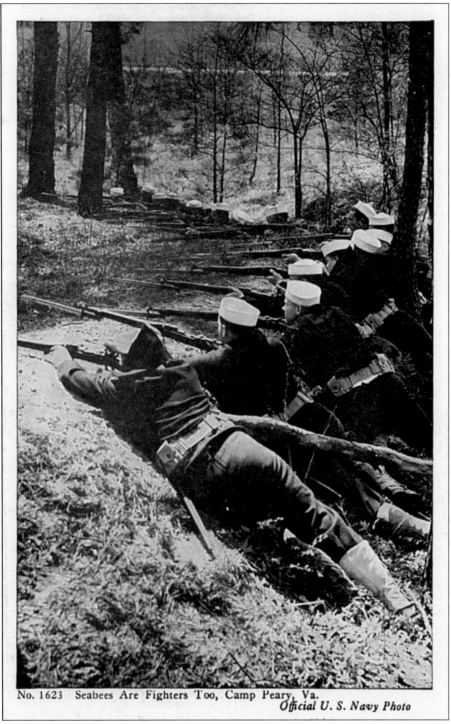

No. 1623 Seabees Are Fighters Too, Camp Peary, Va.
Official U. S. Navy Photo

CAMP PEARY, C. 1943. Seabees also received combat training. During World War II, Camp Peary turned out 85,000 Seabees. Since 1951, Camp Peary has been home to the Armed Forces Experimental Training Activity Area, a training center for the C.I.A. Today it is known affectionately as "The Farm."

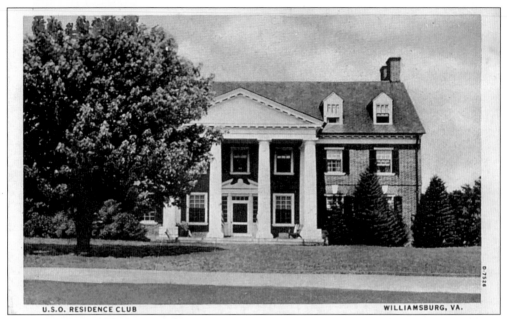

U.S.O. RESIDENCE CLUB

WILLIAMSBURG, VA.

U.S.O. RESIDENCE CLUB, C. 1944. This building at 601 College Terrace housed the Sigma Nu fraternity (Epsilon Iota chapter) in the 1930s, and by the early 1940s, the Alpha Theta chapter of Phi Kappa Tau lived here. It served as Williamsburg's U.S.O. Residence Club from sometime during the Second World War until September 1946. It was the home of Walsingham Academy from 1947 to 1952 and is now the rectory for St. Bede's Catholic Church.

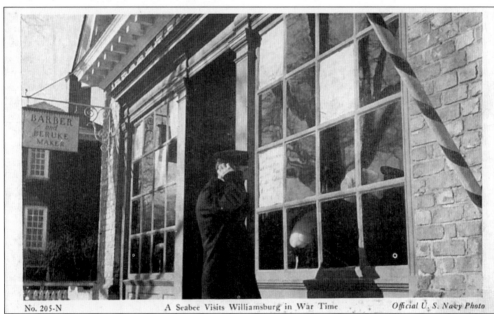

No. 205-N A Seabee Visits Williamsburg in War Time *Official U. S. Navy Photo*

A SEABEE VISITS WILLIAMSBURG, C. 1943. Here, a Seabee from Camp Peary contemplates purchasing a wig from the Barber and Peruke Maker Shop in Colonial Williamsburg to wear over his crew-cut. Most of Colonial Williamsburg's craft exhibits, including this one, were temporarily shelved for the duration of the war. In the background to the left is the Ludwell-Paradise House.

Four
HOME AWAY
FROM HOME

By the 1881 Yorktown Centennial, when the first stirrings of tourism could be felt in Williamsburg, there were only two inns in town. Together, they could comfortably accommodate 60 people. Train tracks were laid in the middle of Duke of Gloucester Street for the event, but no one ever traveled on it. The tracks were soon moved north of town, close to where they pass today. By the 1880s, the Colonial Inn on Duke of Gloucester Street had adequate space to meet the lodging needs of Williamsburg's thriving, if small, tourist industry. Furthermore, the inn was conveniently located at the center of town and close to where the C&O depot would be built in 1881. In 1889, the APVA opened the Powder Magazine as a museum, and the city licensed tour guides to show occasional travelers what traces of colonial history were still visible.

J.B.C. Spencer, a prominent figure in Williamsburg in the late 19th and early 20th centuries (and by many accounts quite a character), owned the Colonial Inn around the time of the 1907 Jamestown Exposition in Norfolk. Spencer did as much to promote Williamsburg's attractions as the APVA did to save them. The Jamestown Exposition was not the most successful venture of its kind, but it served to remind the nation that Williamsburg was worth visiting. The Hotel Williamsburg and Raleigh Hotel, both on Duke of Gloucester Street, served visitors in the early 20th century along with the Colonial Inn, which at some point in the 1920s would be renamed the Colonial Hotel. Topping's Tourist Inn opened in 1925 just east of town. Nevertheless, Williamsburg was still only a stopping point on the way to other places and not a destination in its own right. That would change with the establishment of Colonial Williamsburg.

At its inception, the purpose of Colonial Williamsburg was to inspire patriotic sentiment in visitors—visitors who were not expected to stay very long. Consequently, for years there was not much in the way of lodging for tourists other than guest houses or tourist homes (they were not called bed-and-breakfasts in those days). Local residents quickly saw the profit to be made in renting rooms to tourists who wished to stay overnight. Indeed, Colonial Williamsburg, reluctant at first to enter the hotel business itself, encouraged local residents to do just that. Dozens of guest houses sprouted up in the 1930s. Iron Bound Cottages, with its row of tiny cabins, opened on Richmond Road sometime in the early 1930s. Several buildings were constructed expressly as guest houses, such as The Selby on College Terrace (then called Blair Avenue) and Davis Guest House on Richmond Road.

Soon after the Williamsburg Inn was built in 1937, it was realized that more affordable lodging was necessary for citizens of more modest means. With that in mind, Williamsburg Lodge was opened in 1939. It met with competition, however, from George Constantino's Tioga Court on Richmond Road, which also offered affordable lodging within walking distance of the historic area, and from H.G. Munden's Williamsburg Tourist Court west of town on Route 60. These pioneering motels were the vanguard of tremendous growth in the Williamsburg tourist industry in the 1940s and 1950s. Motels sprang up on Richmond Road as far away as Toano. Today these charming relics of America's postwar passion for travel are quickly disappearing to be replaced by large, multi-story modern structures, bringing another chapter in Williamsburg's history to a close.

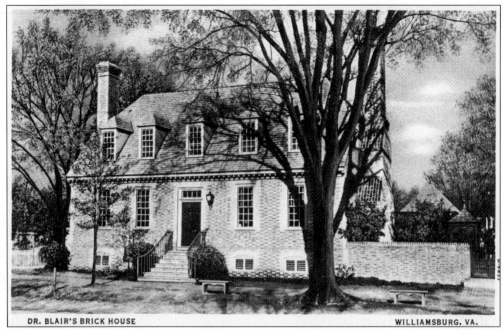

DR. BLAIR'S BRICK HOUSE WILLIAMSBURG, VA.

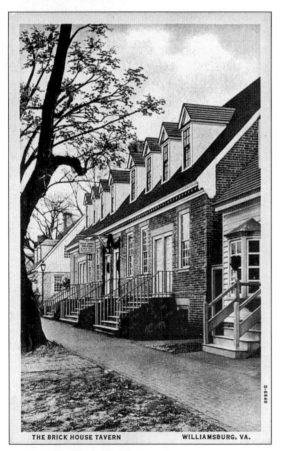

THE BRICK HOUSE TAVERN WILLIAMSBURG, VA.

THE RED LION/BLAIR'S BRICK HOUSE, C. 1942. In the 18th century, taverns were not merely places to eat and drink—they often doubled as inns. Reconstructed on its original foundations, this building next to the Ludwell-Paradise House was used as a tavern from the early 1700s until at least the early 1800s, when it was known as the Union Tavern. The building contained an antique shop when it was known as Blair's Brick House. (From the Carlton Casey collection, Swem Library, College of William and Mary.)

BRICK HOUSE TAVERN, C. 1942. Brick House Tavern is located on the southwest corner of Duke of Gloucester and Botetourt Streets. The original Brick House Tavern was built in the early 1760s and was the colonial equivalent of an apartment complex. Itinerant merchants often sought lodging here. The modern Brick House Tavern, reconstructed on the site of the original, opened in 1940. A fire in March 1950 killed one visitor and injured another, leading to an overhaul of the Williamsburg Fire Department.

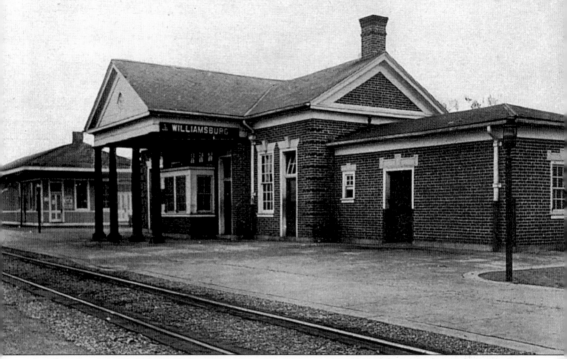

CHESAPEAKE AND OHIO DEPOT, C. 1911. Even though it resembles the modern-day bus and train station, the foreground structure was a different building. This C&O depot was built in 1907 just west of where North England Street today empties into Lafayette Street, a thoroughfare which would not exist until the late 1930s. The site, east of the Governor's Palace, is approximately the size of a modern parking lot. The wooden structure to the left (east) is listed as a freight house on fire insurance maps, but it began its career as the original C&O depot, dating to the 1880s. The depot above was replaced in 1935 with a larger structure on North Boundary Street, some of the materials for which were taken from the old depot. Between 1881 and 1935, these two buildings welcomed thousands of visitors to Williamsburg, witnessing the city's birth as a tourist destination.

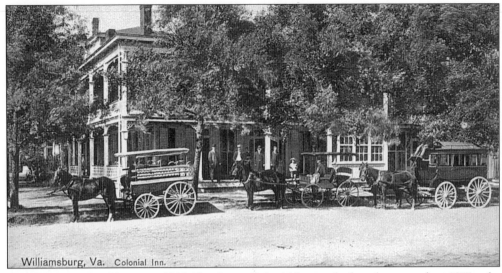

Williamsburg, Va. Colonial Inn.

THE COLONIAL INN/HOTEL, c. 1910. The elegant Colonial Inn was built perhaps as early as 1857 at the eastern edge of Courthouse Green by Dr. Samuel S. Griffin on the spot where Chowning's Tavern was later reconstructed. It was used as a Union commissary in 1862. At first, it did not have its signature porches on the sides facing Duke of Gloucester Street and Courthouse Green. The building was later expanded greatly to the rear late in the 19th century, lending it a sprawling aspect. J.B.C. "Jack" Spencer, the owner from the late 19th century until 1923, was one of the people primarily responsible for promoting Williamsburg around the time of the 1907 Jamestown Exposition (although he no doubt scared a few tourists away with his propensity to sit on the porch with a loaded gun). It had comfortable beds but thin walls and the cost to stay there was between $2 and $2.50 per day.

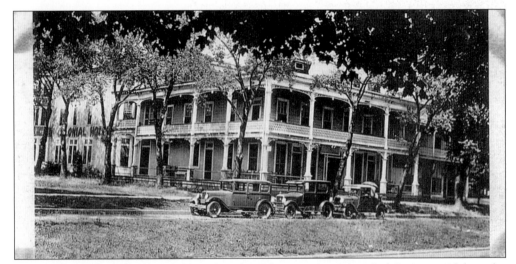

THE COLONIAL INN/HOTEL, c. 1929. Early in the 20th century, proprietor Jack Spencer used the parlor and dining room to display his valuable collection of colonial furniture, books, and antiques. The dining room was occasionally used as a dance hall. W.A. Bozarth bought the hotel in 1923, and Rev. W.A.R. Goodwin bought it from Bozarth in 1927. Colonial Williamsburg remodeled it in the mid-1930s and screened in the porches. It bore the name Williamsburg Inn until the modern hotel of that name was built in 1937, after which time this hotel was known as the Inn Annex. At least for the period just before its demolition in April 1939, it was painted yellow.

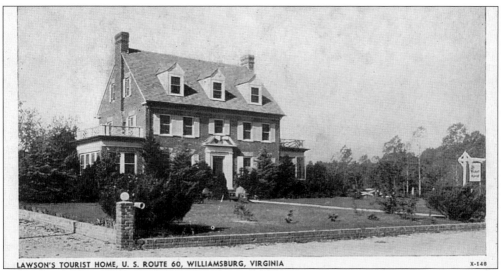

LAWSON'S TOURIST HOME, U. S. ROUTE 60, WILLIAMSBURG, VIRGINIA X-148

LAWSON'S TOURIST HOME, C. 1940. Lawson's Tourist Home, which had 10 rooms and 5 bathrooms, was located on the 1300 block of Richmond Road, where Staples now stands. The building later served as Garrison's funeral home for some time, and still later it housed a florist business. In the late 1960s or early 1970s it was moved back from Richmond Road to 1310 Garrison Drive, a short street behind Staples. Today the old tourist home houses Lawson Enterprises, Inc., a rental property business.

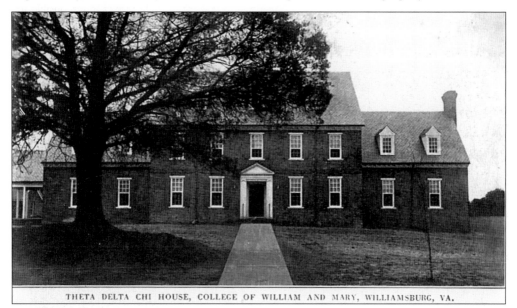

THETA DELTA CHI HOUSE, COLLEGE OF WILLIAM AND MARY, WILLIAMSBURG, VA.

SUSSEX HOUSE/THETA DELTA CHI HOUSE, C. 1932. This house was built at 606 Richmond Road between 1928 and 1931 in the College Terrace subdivision. It originally housed the Theta Delta Chi fraternity (Epsilon Charge) at William and Mary. Ownership passed to the College in 1944. In 1951, Robert and Kathryn Duncan bought and operated it as a tourist home with a gift shop in the front hall. In 1953, the Duncans sold it to Elizabeth Shelley, who continued to rent rooms to students but also used it to teach a kindergarten and to give dance lessons. She sold it to John and Barbara Murphy in 1969. Elizabeth Taylor was here briefly with husband John Warner to kick off his Senate campaign. Barbara C. (Murphy) Baganakis lives there still.

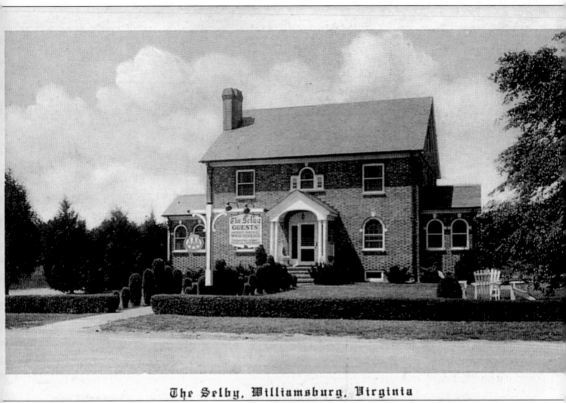

The Selby, Williamsburg, Virginia

THE SELBY, *C.* 1940. The former Selby Guest Home is situated at 702 College Terrace, on the corner of Dillard Street. It was built *c.* 1937 by Spanish and French professor Victor Iturralde and his wife, Mary Selby Iturralde, expressly to house students (in winter) and tourists (in summer). All but one of its eight guest rooms had a bathroom with a shower, and for a while it had two kitchens, one on the first level and one upstairs. The hedge has long since disappeared, but cedar trees along Dillard Street (left) still stand tall—not as tall as they could have been, because a previous owner trimmed off the tops to sell as Christmas trees. Today, the Selby is owned by the Bryants, who still let four of the rooms to students.

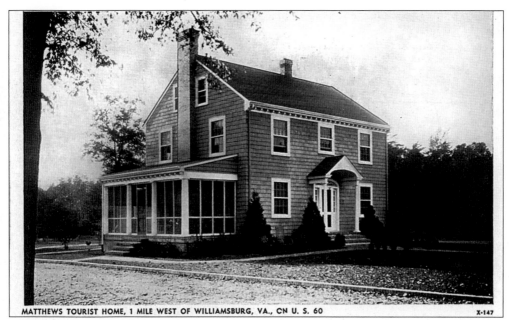

MATTHEWS TOURIST HOME, 1 MILE WEST OF WILLIAMSBURG, VA., CN U. S. 60 X-147

MATTHEWS TOURIST HOME, C. 1940. Matthews Tourist Home (later Fitchett's Tourist Home) was located at 1426 Richmond Road next to Butt's Furniture, near where Bypass Road now intersects with Richmond Road. To its south stood Matthews Tourist Court, a row of four rooms built c. 1946. Lura Binford Marston Fitchett (Mrs. K.L. Fitchett) bought the house from Charles Matthews in 1946 and operated it until her death in August 1973. It was torn down in the summer of 1987, leaving a vacant lot.

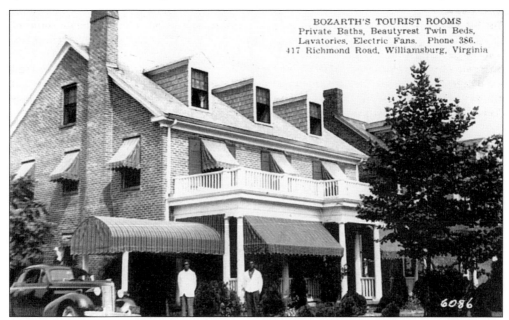

BOZARTH'S GUEST HOUSE, C. 1940s. Bozarth's Guest House stood at 417 Richmond Road, at its intersection with Virginia Avenue. Operated by Mary Casey (Mrs. Frank D.) Bozarth, the Williamsburg Hospitality House now occupies this and neighboring lots. Bozarth's had steam heat, private baths, electric fans, and "circulating ice water."

63

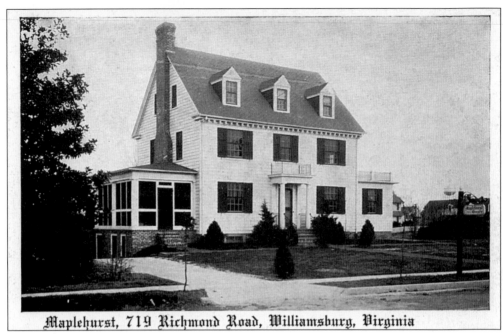

Maplehurst, 719 Richmond Road, Williamsburg, Virginia

MAPLEHURST, *C.* 1940S. Maplehurst still stands at 719 Richmond Road. It is no longer a tourist home, but it contains seven rented apartments.

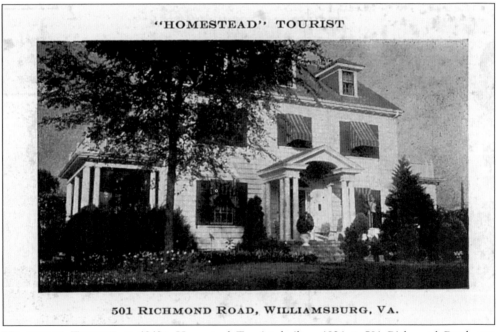

"HOMESTEAD" TOURIST

501 RICHMOND ROAD, WILLIAMSBURG, VA.

HOMESTEAD TOURIST, *C.* 1940S. Homestead Tourist, built *c.* 1926 at 501 Richmond Road, was operated by Mrs. Harry D. Bozarth. Today it is called the Colonial Capital Bed and Breakfast and has been owned and operated by Barbara and Phil Craig since 1988.

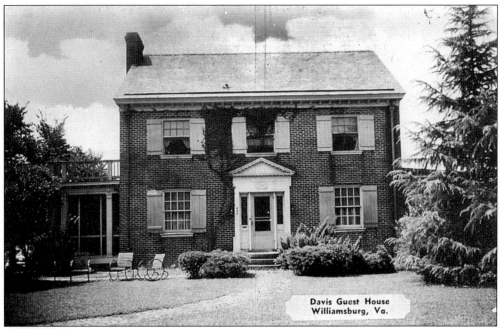

Davis Guest House
Williamsburg, Va.

DAVIS GUEST HOUSE, C. 1950S. Davis Guest House, an elegant six-bedroom, five-bathroom brick colonial structure, was erected at 600 Richmond Road *c.* 1927 under the ownership of Mrs. E.T. Davis. It was originally built to house faculty at William and Mary. Around 1962, it changed ownership, was remodeled, and became York Lodge. It still serves guests today as the Williamsburg Manor Bed and Breakfast, owned and operated by Laura Reeves since 1992.

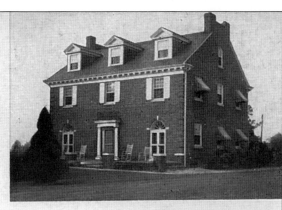

Write or Wire for Reservations

Middlesex Guest House

415 Richmond Road
(Route 60)
WILLIAMSBURG, VIRGINIA·

PRIVATE BATHS PARKING FOR GUESTS

Member of the Williamsburg Chamber of Commerce

 The Middlesex Guest House is in walking distance of all restored and rebuilt buildings and gardens of Colonial Williamsburg. These are open to the public every day of the year except Christmas. Just across campus of William and Mary College is the Matoaka Lake Amphitheatre where Paul Green's "The Common Glory" plays during the summer months. The Middlesex Guest House is also in walking distance of hotels, antique shops and the business district of Williamsburg.

MIDDLESEX GUEST HOUSE, C. LATE 1940S–1950S. Middlesex Guest House stood at 415 Richmond Road, one of the lots on which the Williamsburg Hospitality House is now situated. Rooms were $1.25 per person. In the 1930s it housed the Sigma Phi Epsilon fraternity (Virginia Delta chapter).

65

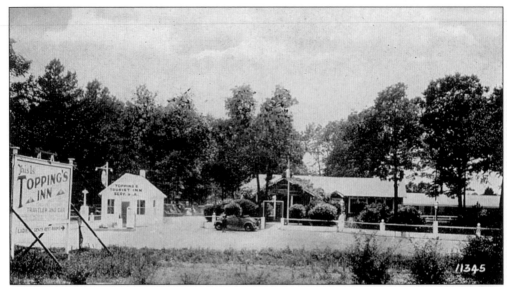

TOPPING'S TOURIST INN, C. 1940. Established by William E. Topping in 1925, Topping's was billed by its owner as the first tourist camp in Virginia. Topping was a Shell Oil merchant—the inn's service station can be seen toward the left, and the concrete-and-pipe fence is topped with shell-shaped lamps. The site is now occupied by the Radisson Fort Magruder Hotel and Stonegate Apartments. The structures in the postcard are gone, but Topping's house still stands next to Pocahontas Trail (Route 60) just east of town. When the inn's occupancy exceeded its vacancies, Topping would take guests into his home. A bend in the apartment complex's road called "Topping Circle" is all that remains to commemorate the presence of the inn.

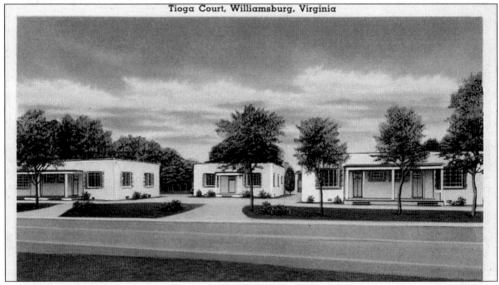

TIOGA MOTOR COURT, C. 1938. Tioga Court was built in 1938 by Homer E. Cox of Cox Construction, and it was owned by Mr. and Mrs. George Constantino of Tioga, New York. In 1966, the owners of the Tioga moved the two front buildings apart, rotated each of them 90 degrees so that they faced one another, and installed a swimming pool between them. The Tioga may be the oldest single-story motor court in Virginia. It is currently owned and operated by Cox's sister-in-law, Evelyn Lee.

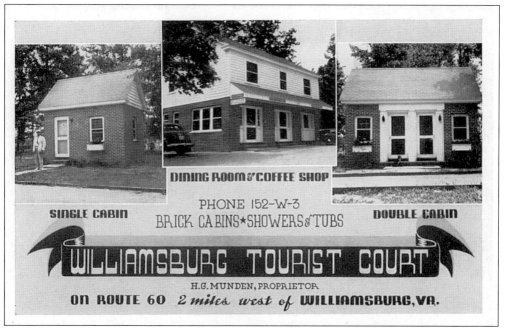

WILLIAMSBURG TOURIST COURT, C. 1940. Williamsburg Tourist, located at 2200 Richmond Road, is still in operation today as Williamsburg Motor Court. It was one of the first motor courts in the vicinity of Williamsburg and was very popular with tourists.

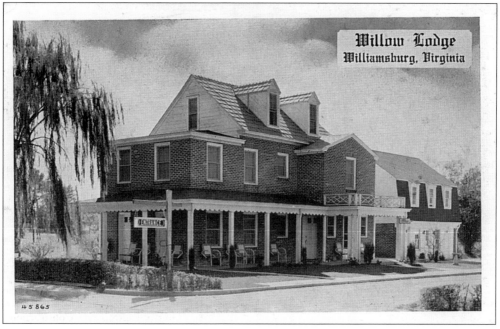

WILLOW LODGE, C. 1950. Willow Lodge, operated by Mr. and Mrs. A.G. Rodgers, were located at 1330 Richmond Road, where the western wing of Heritage Inn now sits. The western building of Willow Lodge, facing these but not pictured here, now houses the Library Tavern. A dilapidated and unused section of rooms once belonging to Willow Lodge sits at the back of the parking lot.

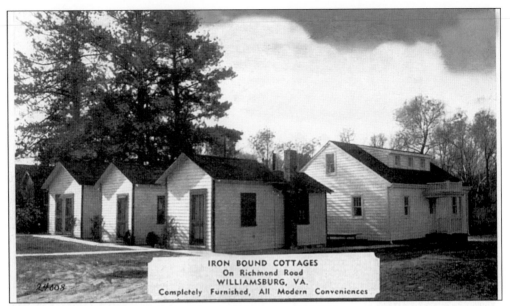

IRON BOUND COTTAGES
On Richmond Road
WILLIAMSBURG, VA.
Completely Furnished, All Modern Conveniences

IRON BOUND COTTAGES, C. 1945. This establishment at 1220 Richmond Road existed at least as far back as 1933, consisting of three or four tiny cabins behind a gas station. The cabins remained into the 1940s, when they were replaced with rows of more standard motel rooms.

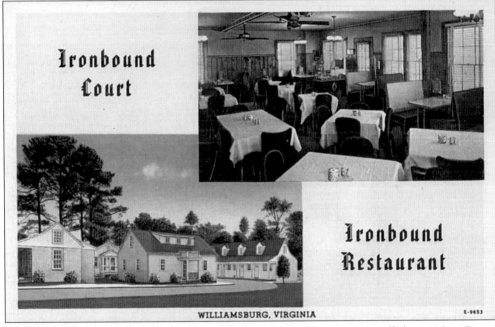

Ironbound Court

Ironbound Restaurant

WILLIAMSBURG, VIRGINIA

IRONBOUND COURT AND RESTAURANT, C. 1950s. Iron Bound Cottages eventually became Iron Bound Inn and then Ironbound Court, boasting 21 rooms, a restaurant, and a swimming pool. It operated until recently as the Southern Inn and is now vacant. The graceful, curving drive is now a narrow alley between the inn and a raised parking lot for the neighboring Williamsburg Shopping Center. The porch on the central building and the dormer windows on the rear building have been removed. These buildings will likely be demolished in the near future.

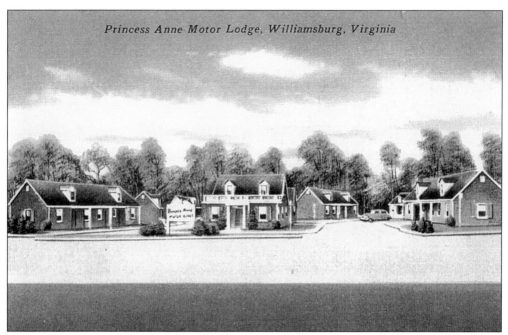

Princess Anne Motor Lodge, Williamsburg, Virginia

PRINCESS ANNE MOTOR LODGE, C. 1946. The 40-unit Princess Anne still operates at 1350 Richmond Road. It has since expanded to 71 rooms.

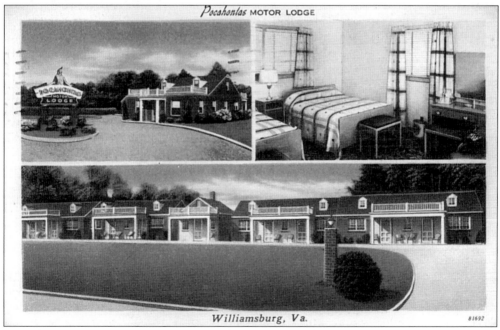

Pocahontas MOTOR LODGE

Williamsburg, Va.

POCAHONTAS MOTOR LODGE, C. 1950. Pocahontas Motor Lodge was located at 900 Capitol Landing Road and sported "54 handsomely furnished air-conditioned rooms with baths." These buildings still stand but now make up International Housing Village, lodging for seasonal Busch Gardens employees.

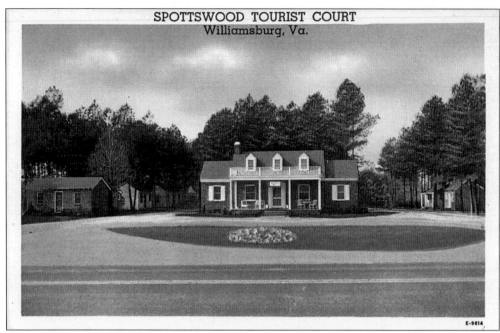

SPOTTSWOOD TOURIST COURT
Williamsburg, Va.

SPOTTSWOOD TOURIST COURT, C. EARLY 1950S. Spottswood Tourist Court, later the Governor Spottswood Motel, was run by W.H. Legge throughout the 1950s and 1960s at 1508 Richmond Road. It is still open for business as the Budget Host Governor Spottswood. The building pictured here still stands but has undergone several major remodelings making it almost unrecognizable.

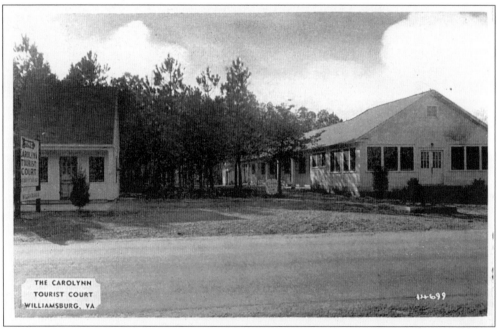

THE CAROLYNN
TOURIST COURT
WILLIAMSBURG, VA

CAROLYNN TOURIST COURT, C. 1949. Carolynn Court was built by Mr. and Mrs. J.L. Matteson after they managed the Tioga. Located at 1446 Richmond Road, it is still in operation. However, the small building on the left no longer stands.

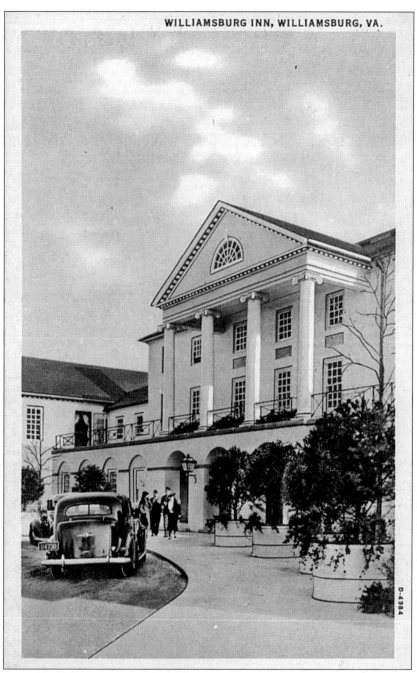

WILLIAMSBURG INN, C. 1937. Colonial Williamsburg initially held some reservations about entering the hotel business, but there was a pressing need to provide top-quality overnight lodging for guests. In the end, necessity won out. Perry, Shaw, and Hepburn, the same architectural firm that handled the original restoration work for Colonial Williamsburg, designed Williamsburg Inn. The hotel opened in April 1937 south of Francis Street, just outside the historic area. Itself on the National Register of Historic Places, the Williamsburg Inn originally contained 61 rooms at $9.50 per night. It was completely overhauled in 2000–2001, enlarging the rooms and returning the inn as close to its 1937 appearance as possible.

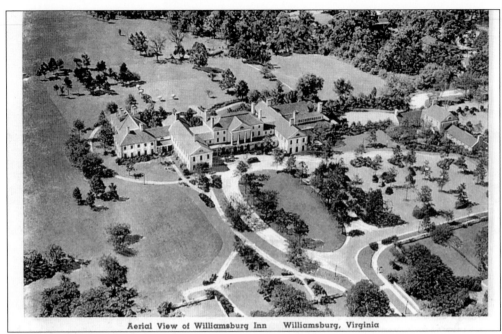

Aerial View of Williamsburg Inn Williamsburg, Virginia

WILLIAMSBURG INN, C. 1939. Williamsburg Inn was the first hotel in the nation to have central air conditioning. During World War II, it was reserved for military personnel, its dining room serving as an officer's club. Much of the area visible behind the inn in this postcard is now a golf course. A nine-hole course opened in 1947; designer Robert Trent Jones expanded the course to 18 holes in 1963, and it was named the Golden Horseshoe. It was fully renovated in 1998 under the supervision of Jones's son, Rees.

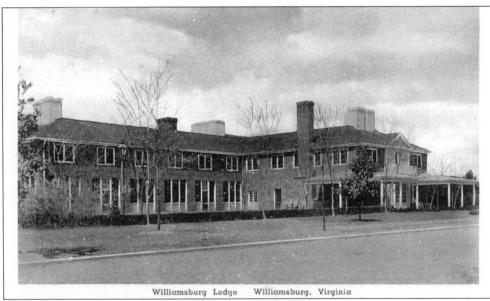

Williamsburg Lodge Williamsburg, Virginia

WILLIAMSBURG LODGE, C. 1939. Williamsburg Lodge, viewed from the southeast, began construction in 1937 and opened in 1939. The lodge was built across South England Street from the Williamsburg Inn as a more affordable alternative. Part of it occupies the site of the colonial Cary House, which burned in December 1907. A southern extension of the lodge occupies the former site of Tazewell Hall.

Five

A GOOD PLACE TO EAT

During Williamsburg's heyday as Virginia's colonial capital, the elite gathered in the town twice yearly to make laws and mete out justice. Quality victuals were a must during these "Publick Times." Several taverns arose along Duke of Gloucester Street, as well as on some back streets, to accommodate the demand. The Raleigh Tavern was hugely popular, not least for innkeeper Henry Wetherburn's arrack punch, a chilled concoction of rum and fruit. Wetherburn, who came to own two other inns by marriage, was not alone in his enterprise. Christiana Campbell ran a coffee shop at a prime location next to the Capitol, and later opened her own tavern. Josiah Chowning, Jane Vobe, and John Redwood were other noted colonial tavernkeepers.

With the coming of the Restoration, several colonial taverns were reconstructed on or near their original foundations, including the King's Arms, the Raleigh, Shields, and Christiana Campbell's. The Victorian Colonial Inn, looking somewhat out of place amid its 18th-century neighbors, was demolished to make room for the resurrected Chowning's Tavern in 1941. Two taverns, Market Square Tavern and Wetherburn's, did not need to be reconstructed, because they had served variously as hostelries, taverns, and homes since their construction in the middle of the 18th century. Today, there are plans to reconstruct Christiana Campbell's coffee house on the site of the Dora Armistead House, near the Capitol.

The creation of Colonial Williamsburg led to an ever-increasing influx of tourists in need of good food, prompting major growth in the local restaurant business. Today the hungry visitor to Williamsburg is confronted with a difficult decision (one has only to drive down Richmond Road to see why!), but in the early days of the Restoration there were few choices. Visitors with money typically ate at Williamsburg Inn or Lodge, while others enjoyed excellent fare at the various Greek restaurants or in either of the city's two drug stores. There was also the independently operated Richard Bland Tavern on Duke of Gloucester Street (the once and future Wetherburn's), which was opened as a restaurant in 1931.

Williamsburg's Greek community has played a major role in Williamsburg's restaurant business since Rockefeller's project got underway. The Greek-owned Norfolk Cafe had served locals and tourists alike since 1916, and Angelo Costas and Tom Baltas opened their popular Capitol Restaurant in 1932 in what would become Merchants Square. Caterers Steve and Chrysa Sacalis opened several restaurants, including the Colonial Restaurant and the Lafayette Charcoal Steak and Seafood House (now home to the Cornerstone Grill). Many Williamsburg restaurants are still owned and operated by members of the Greek community.

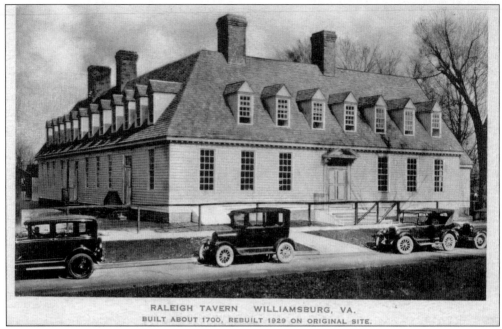

RALEIGH TAVERN WILLIAMSBURG, VA.
BUILT ABOUT 1700, REBUILT 1929 ON ORIGINAL SITE.

THE RALEIGH TAVERN, C. 1930. The Raleigh Tavern was rebuilt on its original foundations in 1929–1932. The original Raleigh Tavern was built *c.* 1717 and was the most popular hostelry in town until well into the 19th century. Colonial legislators met here more than once to protest taxes on British imports. The Phi Beta Kappa Society was founded here in 1776. The western face (left) is now obscured by the reconstructed Unicorn's Horn and John Carter's Store. (From the Carlton Casey collection, Swem Library, College of William and Mary.)

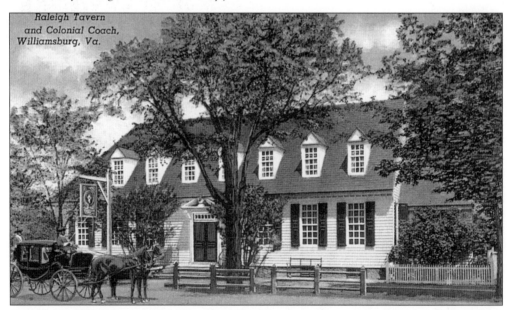

Raleigh Tavern and Colonial Coach, Williamsburg, Va.

THE RALEIGH TAVERN, C. 1938. The original building having burned in 1859, the rebuilt Raleigh Tavern was officially opened on September 16, 1932, when tours were offered for 40¢. The tavern was to gain shutters soon after reconstruction.

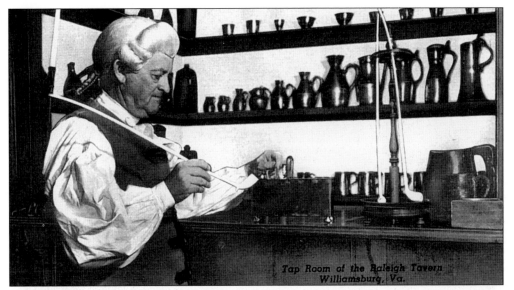

Tap Room of the Raleigh Tavern
Williamsburg, Va.

THE TAP ROOM OF THE RALEIGH TAVERN, C. 1951. One of the documented tavern keepers at the Raleigh was Henry Wetherburn, who owned other taverns in town as well. The interpreter above stands in the bar's tap room, which was literally enclosed by bars to protect merchandise when the barkeep had to leave the room.

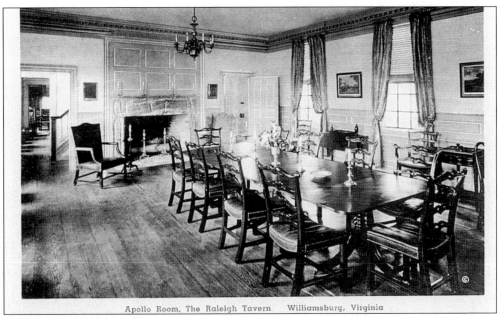

Apollo Room, The Raleigh Tavern Williamsburg, Virginia

RALEIGH TAVERN, THE APOLLO ROOM, C. 1935. Two sketches made by traveler and writer Benson Lossing in 1848 were crucial to the reconstruction of the Raleigh's famous Apollo Room. It is thought that the Apollo Room, where by tradition the Phi Beta Kappa Society was founded, was named for a room in London's Devil's Tavern, a favorite watering hole of Sir Walter Raleigh. The motto over the mantel reads "Hilaritas Sapientiae et Bonae Vitae Proles"—"Jollity, the offspring of wisdom and good living." It was in the Apollo Room that the colonial House of Burgesses held secret meetings before the American Revolution, despite having been dissolved more than once.

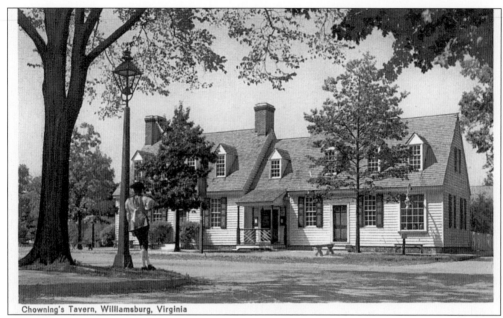

Chowning's Tavern, Williamsburg, Virginia

CHOWNING'S TAVERN, C. 1949. Chowning's Tavern, a mid-18th century hostelry, was reconstructed at the eastern side of Courthouse Green near (but not at) its original location. Josiah Chowning's original tavern lasted only two years. The modern version having been serving colonial fare since 1941. Its Brunswick stew and colonial entertainment are justifiably famous.

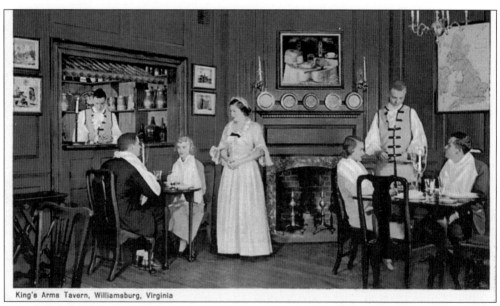

King's Arms Tavern, Williamsburg, Virginia

KING'S ARMS TAVERN, C. 1951. King's Arms Tavern was reconstructed on the site of the original tavern established by Jane Vobe in 1772. It was built directly across the street from, and in competition with, the Raleigh Tavern. The name "King's Arms" understandably became unpopular during Revolutionary times, so the name was changed to Mrs. Vobe's and later still to the Eagle Tavern. This and other reconstructed taverns have provided employment for many college students over the years. Hungry travelers can order peanut soup, game pie, oyster-stuffed filet mignon, and other colonial dishes.

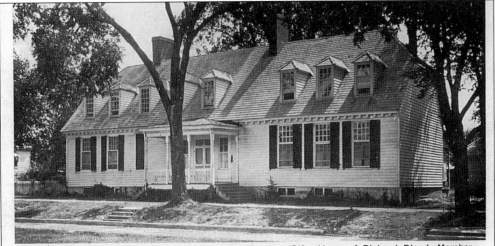

WILLIAMSBURG, VIRGINIA. Richard Bland Tavern, 1710. Home of Richard Bland, Member of the First Continental Congress, Still Extends to All the Hospitality of Colonial Days. Rooms Individually Named such as Great Chamber, Mr. Page's Room, Bull Head Room. This House was Once Owned by Henry Wetherburn, Keeper of the Raleigh Tavern.

WETHERBURN'S TAVERN, C. 1930. This building, also known as the Bland-Wetherburn House, was erected in the 1740s, perhaps earlier. Raleigh Tavern keeper Henry Wetherburn operated it as a tavern during the mid-18th century. It was purchased from Miss Kitty Morecock by Virginia Braithwaite Haughwout in 1921, but Miss Kitty continued operating a tea room there for some time. It operated as a restaurant named the Richard Bland Tavern (at the Sign of the Bull's Head) from 1931 to *c.* 1945, and it contained a gift shop until it closed in 1957.

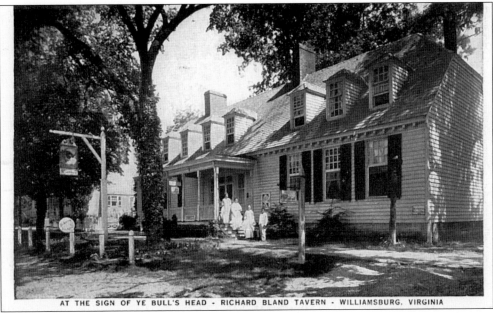

AT THE SIGN OF YE BULL'S HEAD · RICHARD BLAND TAVERN · WILLIAMSBURG. VIRGINIA

WETHERBURN'S TAVERN, C. 1937. In 1966, the Bucktrout-Braithwaite Memorial Foundation leased the Bull's Head to Colonial Williamsburg for 100 years. Restoration of the tavern, undertaken that same year, involved extensive archaeological digs and replacing the single central door with two off-center doors, as in the original structure. Now called Wetherburn's Tavern, it was recently painted a shade of brownish-red similar to that on the Peyton Randolph House.

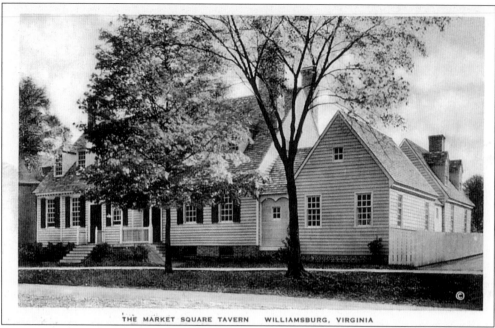

THE MARKET SQUARE TAVERN WILLIAMSBURG, VIRGINIA

MARKET SQUARE TAVERN, C. 1936. Market Square Tavern was built *c.* 1749 and has served as either a public house or tavern since that time. It was known as the Raleigh Hotel between 1859, when the Raleigh Tavern burned, and the Restoration. Returning the building to its colonial appearance in 1931–1932 involved replacing the second story with a dormered half-story, as well as the reconstruction of several support structures. In the 1960s, one room was used one night per week for tourists (by appointment) to learn how to play colonial games of chance.

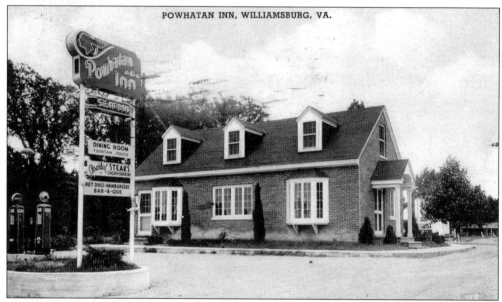

POWHATAN INN, WILLIAMSBURG, VA.

POWHATAN INN, C. 1941. Powhatan Inn was located just east of town on Route 60. In addition to offering meals, it advertised complete tourist accommodations. The building no longer stands. (From the Carlton Casey collection, Swem Library, College of William and Mary.)

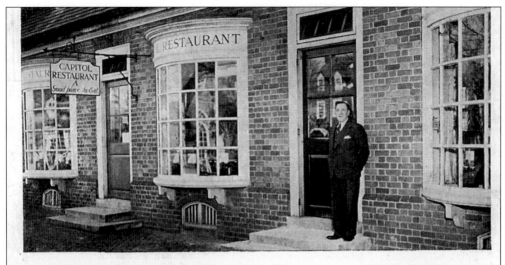

THE CAPITOL RESTAURANT, Duke of Gloucester Street, Williamsburg, Va.

THE CAPITOL RESTAURANT, C. 1930S. The Capitol, a joint venture of Greek entrepreneurs Angelo and Dora Costas and Tom and Helen Baltas, opened in 1932 in Merchants Square on the south side of Duke of Gloucester Street. It was affectionately called "The Middle Greeks" because of its location at the middle of the block. In the postcard above, Tom Baltas stands in the doorway. After the Capitol was sold *c.* 1960, Angelo Costas opened the Colonial Motel, which was demolished in 2000, on Richmond Road. Tom Baltas opened Baltas's Dairy Bar later that year on Route 168 (now Route 143, Merrimac Trail).

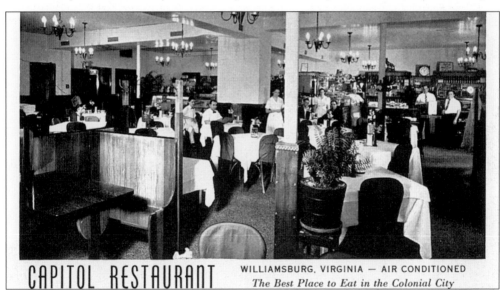

CAPITOL RESTAURANT WILLIAMSBURG, VIRGINIA — AIR CONDITIONED
The Best Place to Eat in the Colonial City

THE CAPITOL RESTAURANT, C. 1940S. After an interior renovation *c.* 1951–1952, the Capitol Restaurant featured green linoleum flooring, green tables, and orange-upholstered chairs and booths. The two men standing in the back are owners Angelo Costas (left) and Tom Baltas (right). Seated to the left of the column in the center is Tom Antoniadis, a third partner in the enterprise for a while. The Capitol billed itself as "the largest and best place to eat in the colonial city" and "a good place to eat." Until recently there was still a restaurant in Merchants Square called A Good Place to Eat. Today, this building houses Scotland House, Ltd., purveyors of Scottish apparel and accessories.

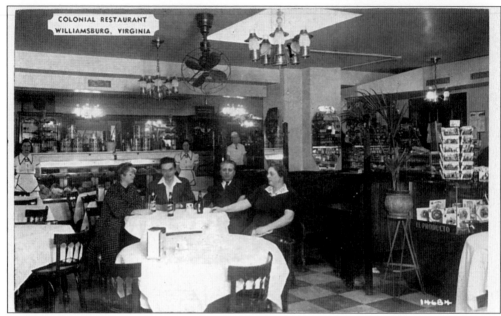

THE COLONIAL RESTAURANT, C. 1939. The Colonial Restaurant, the "Famous Home of Good Food," was located on the north side of Duke of Gloucester Street in Merchants Square. Built between 1930 and 1932, it was owned by Steve Sacalis until the summer of 1941 when he sold it to his brother Alexander Sacalis. Standing, from left to right, are waitresses Minnie and Virgie. The man behind the counter is likely Leon Zaharis. Proprietor Steve Sacalis and his wife, Chrysa "Mama Steve" Sacalis, sit on the right side of the table. Notice that the Colonial sold many things other than food—among them, postcards!

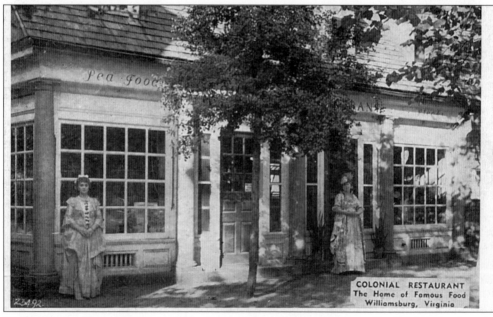

THE COLONIAL RESTAURANT, C. 1940S. On the left is Nina Zaharis (Steve Sacalis' sister) and on the right is her sister-in-law Helen Vena Sacalis. Alexander Sacalis bought the restaurant from Steve in 1941, eventually bringing Nina and her husband Charles Zaharis in as partners.

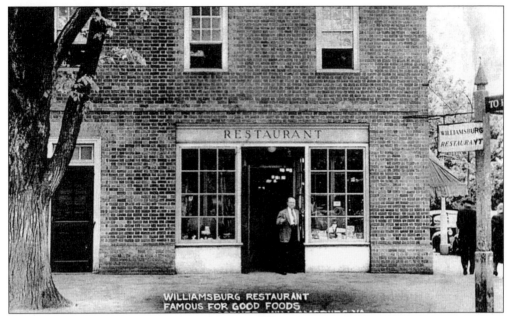

WILLIAMSBURG RESTAURANT, C. LATE 1940S. Legendary Williamsburg restauranteur Steve Sacalis stands in the front door of his Williamsburg Restaurant, which was located in the building in Merchants Square at the western terminus of Duke of Gloucester Street. This restaurant was known as "The Corner Greeks" to distinguish it from "The Middle Greeks" a few doors down the block. This building housed the Williamsburg Drug Company from 1978 to 2002.

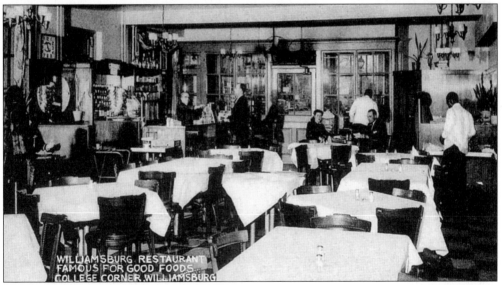

WILLIAMSBURG RESTAURANT, C. LATE 1940S. Steve and Chrysa Sacalis co-owned Williamsburg Restaurant with Louis and Despina Pappas. Here Sacalis serves a patron at the cash register. Seated with a friend is Sylvia Harrison Pittas. After the Pappases left for California, the Sacalises sold the restaurant to Pete and Harriet Beler in 1950. Steve and Chrysa went on to start the Lafayette Charcoal Steak and Seafood House on Richmond Road in 1953. Jim and Ann Graff subsequently took over management of Williamsburg Restaurant.

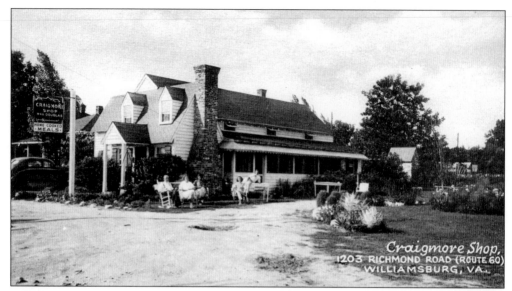

THE CRAIGMORE SHOP, C. 1940–1941. The Craigmore Shop stood at 1203 Richmond Road at the corner of Bacon Avenue. Seated are, from left to right, William Thomas Douglas, his wife Lydia Craig Douglas, Gordon Burleson, an unidentified waitress, and Henry J. (Jeff) Carter. The Craigmore Shop was on the site where the Lafayette Charcoal Steak and Seafood House, run by Steve and Chrysa Sacalis, would later be built. The Sacalises bought the property from Rose Douglas. (From the Carlton Casey collection, Swem Library, College of William and Mary.)

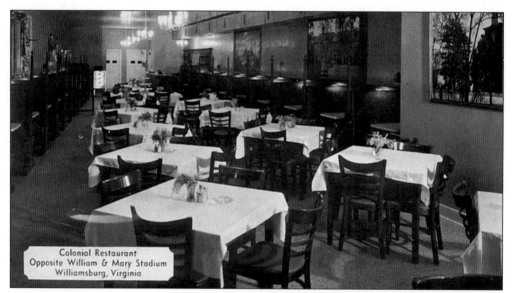

THE "NEW" COLONIAL RESTAURANT, C. 1950S. The "new" Colonial Restaurant, located on the corner of Scotland Street and Richmond Road across the street from William and Mary's football stadium, existed at least as early as 1948. The College used the downstairs bowling alley for league competitions. The Colonial Restaurant was owned by James J. "Jimmy" Seu (arguably William and Mary's most ardent supporter) from 1953 until 1974, when he moved the business to Page Street. The photographs on the wall from right to left, are Bruton Parish Church, the Wren Building, and the Colonial Capitol Building. Since 1974, this restaurant has been the popular Green Leafe Cafe.

Six
CHURCH AND STATE

Citizens of Williamsburg have always looked to two institutions for leadership—the church and the government. From 1699 to 1780, it was in Williamsburg that the royal governors of Virginia lived and worked, and in Williamsburg that the governing bodies of the colony met to review and create laws and to distribute justice. The General Court met twice yearly in the Capitol building to decide difficult cases while prisoners and debtors were detained in the nearby gaol on Nicholson Street. Williamsburg remained the seat of government in Virginia until 1780, when, on Thomas Jefferson's suggestion, the capital was moved inland to Richmond. The move left only Bruton Parish Church and local government in authority (Williamsburg had been incorporated as a city in 1722).

The prison and the new courthouse would remain standing and in use, but the Governor's Palace would burn in 1781, the year Cornwallis surrendered at Yorktown. Part of the Capitol would burn in the 1790s, and the rest would be reduced to rubble in an 1832 fire. The Clerk's Office would become a private residence soon after the Revolution. Williamsburg had neither the money nor any compelling reason to maintain or rebuild these colonial relics. As a result, we know some of the original structures only from their foundations and scantily written records.

Even after Williamsburg ceased to be the center of Virginia's government and culture, religion continued. The city was almost exclusively Anglican for much of its early existence. Bruton Parish Church, with a congregation which predated the city itself, had been the court church of colonial Virginia. It continues today as a working Episcopal church, independent of the Colonial Williamsburg Foundation.

The official separation of church and state in America had its beginnings in Williamsburg. In 1779, a year before the capital moved to Richmond, Thomas Jefferson proposed that the idea be made into law. The Statute of Religious Freedom was passed by the General Assembly in 1786. Sudden freedom from state-controlled religion did not lead to the immediate influx of different faiths—that took time. Baptists had already begun holding meetings in Williamsburg around 1776, and a black Baptist meeting house existed on Nassau Street by 1818. White Baptists had organized by 1793 and began meeting in the Powder Magazine in 1828. Methodists built a church on Duke of Gloucester Street in 1842. Presbyterians had been meeting officially since 1765, and they finally built a church on Palace Green around the end of the 19th century. The area's first Lutheran church was built not far from town on Richmond Road in 1904. There were as many as nine Catholic families in the Williamsburg area in the early 19th century, but Catholicism did not gain a serious footing in Williamsburg until the early 20th century. Mass was offered in Cameron Hall at Eastern State Hospital starting c. 1908 and in a William and Mary chemistry lab during the 1920s. St. Bede's would not be built until 1932. With the exception of Bruton Parish Church, all houses of worship in Williamsburg's historic area have been torn down and their congregations relocated.

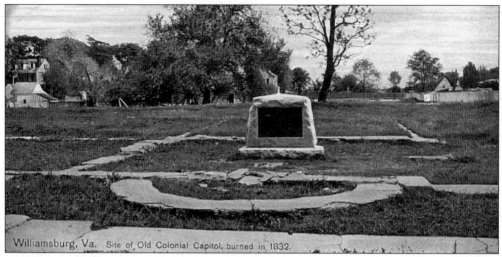

Williamsburg, Va. Site of Old Colonial Capitol, burned in 1832.

THE SITE OF THE COLONIAL CAPITOL BUILDING, C. 1910. The original colonial Capitol building of 1705 burned in 1747. The second Capitol was built using the remaining walls of the first. Part of the building was demolished in 1793 or 1794, and the rest burned in 1832. The crumbling remains of the Capitol's foundations were donated to the APVA in 1897 by the Old Dominion Land Company. The memorial marker, placed amid the foundations by the APVA on May 26, 1904, now sits in one corner of the reconstructed Capitol's yard. An attempt was made in 1909 to reconstruct the Capitol, but it fell through for lack of funds. It was in the building outlined by these foundations that the Virginia Bill of Rights was passed, and where Patrick Henry boldly proclaimed, "Caesar had his Brutus, Charles I his Cromwell, and George III may profit by their example. If this be treason, make the most of it!"

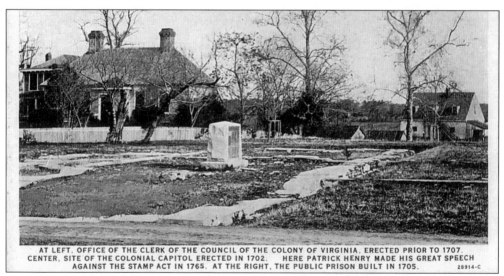

AT LEFT, OFFICE OF THE CLERK OF THE COUNCIL OF THE COLONY OF VIRGINIA, ERECTED PRIOR TO 1707. CENTER, SITE OF THE COLONIAL CAPITOL ERECTED IN 1702. HERE PATRICK HENRY MADE HIS GREAT SPEECH AGAINST THE STAMP ACT IN 1765. AT THE RIGHT, THE PUBLIC PRISON BUILT IN 1705. 28914-C

THE SITE OF THE COLONIAL CAPITOL BUILDING, C. 1911. These are not the actual foundations, but rather cement caps poured by the APVA. The intent was to protect the foundations from the elements and from looters, although the APVA itself used bricks from the site to restore the Powder Magazine. The lot was the site of Lefebvre's relocated Williamsburg Female Academy from 1849 until 1861. The ruins of the academy could still be seen by the time of the Yorktown Centennial Celebration in 1881. Behind the ruins to the left is the Public Records Office (being used as a home), and to the right is the old prison, later restored by Colonial Williamsburg as the Public Gaol.

THE CAPITOL, *C.* LATE 1930S. The west side of the reconstructed H-shaped building contains the General Court downstairs and the Council Chamber and Council Clerk's office above, while the east side contains the House of Burgesses and House Clerk's office below and committee rooms above. The Council represented the crown while the Burgesses represented colonial interests. Over the central piazza is the Conference Room joining the judicial and legislative halves of the building. The Capitol was reconstructed in 1932–1933 to resemble the first colonial Capitol building, for which more architectural evidence was available. The current structure differs markedly from the original for the sake of architectural harmony. For example, the semicircular porch clearly outlined in the foundations was not reconstructed. The Capitol was officially opened on February 24, 1934.

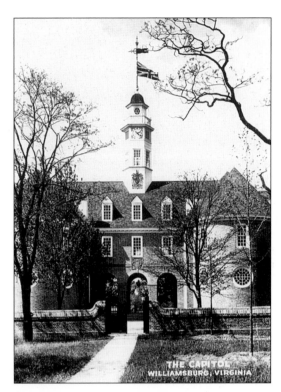

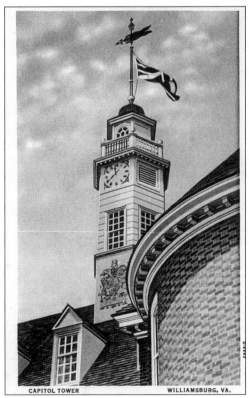

THE CAPITOL, *C.* 1942. The flag flying from the Capitol's cupola is the old "Great Union" flag of Great Britain. This was the flag of Britain in the days when Williamsburg was the capital of the British colony. The superimposed crosses of St. George and St. Andrew symbolize the union of England and Scotland under King James I, after whom the flag is nicknamed the "Union Jack." The clock was taken in 1931 from the tower of Bruton Parish Church, which in turn obtained it from the Courthouse, which may have acquired it from the second Capitol some time before it burned. The historic clock was replaced in April 2002 out of preservation concerns.

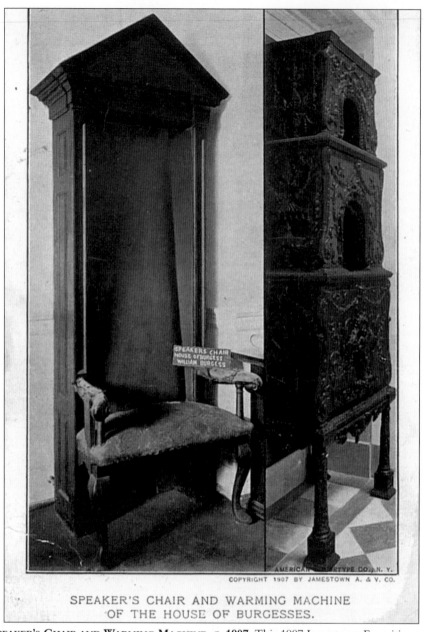

COPYRIGHT 1907 BY JAMESTOWN A. & V. CO.

SPEAKER'S CHAIR AND WARMING MACHINE
OF THE HOUSE OF BURGESSES.

THE SPEAKER'S CHAIR AND WARMING MACHINE, C. 1907. This 1907 Jamestown Exposition postcard features the Speaker's Chair and the cast-iron warming machine ("Botetourt's Stove"), which sat in the colonial Capitol building until both were taken to the new capitol in Richmond in 1780. The Speaker's Chair was fashioned from tulip poplar and black walnut probably about 1733. Scorch marks attest to its narrow escape from the conflagration which destroyed the Capitol in 1747. Its pediment was probably adorned with the royal coat of arms until the Revolution. Its height of over eight feet reflects the relative status of the Speaker of the Virginia House of Burgesses. Long neglected, it was returned to the reconstructed Capitol by the General Assembly of Virginia in 1933. The cast-iron warming machine was made in London by Abraham Buzaglo and presented by Governor Botetourt to the House of Burgesses around 1770. It can be viewed today in the DeWitt Wallace Decorative Arts Museum.

86

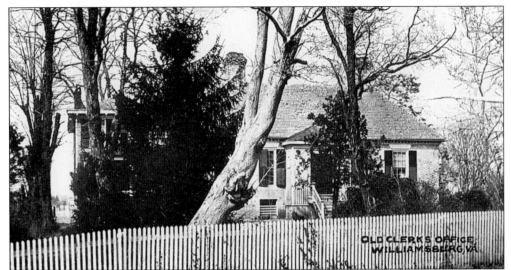

THE PUBLIC RECORDS OFFICE, C. 1913. The Public Records Office, or "Clerk's Office" as it was locally known, was built near the Capitol in 1748 to house public documents. It served as a house from 1784 to 1824, and again from 1855 to 1964. The Public Records Office was acquired in 1937 by Colonial Williamsburg and restored in 1939–1940, the only standing administration building of the colonial government. The turn-of-the-century western extension was finally removed in 1964.

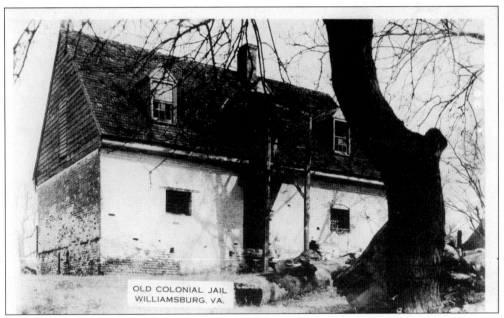

THE OLD PRISON, C. 1930. The old jail, located on Nicholson Street north of the Capitol area, was used in colonial times to temporarily house insolvent debtors, the mentally ill, and criminals awaiting trial. Punishment was swift in those days, so there was little need for a larger facility. This portion of the original jail, constructed between 1701 and 1705 to serve the entire colony, continued to be used as a jail by the city of Williamsburg from 1799 until *c.* 1910. It was deeded to Colonial Williamsburg in 1933, restored in 1935, and opened to the public in 1936. Now much expanded, it is interpreted as the Public Gaol. (From the Carlton Casey collection, Swem Library, College of William and Mary.)

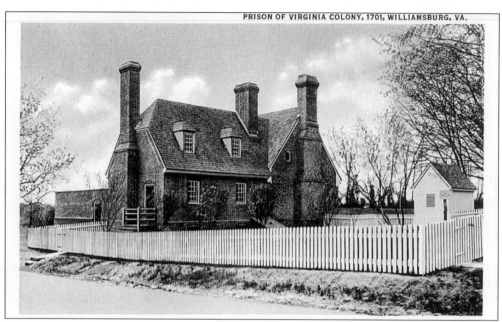

THE PUBLIC GAOL, C. 1936. The Public Gaol accumulated three additions during the colonial era, although only the northern (right) section survived into the 20th century. The upper story served as the jailor's residence. Despite local tradition, Blackbeard, the pirate, never lived in Williamsburg, although 13 of his men were reportedly incarcerated in this gaol in 1718 and hanged on a tree near Capitol Landing Road.

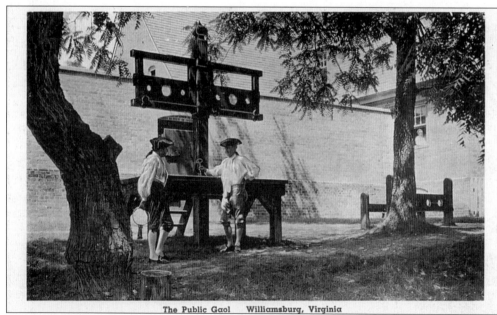

The Public Gaol Williamsburg, Virginia

THE PUBLIC GAOL, C. 1938. The pillory and stocks formerly in place at the Public Gaol have been bizarrely popular since the 1930s; perhaps hundreds of thousands of tourists have been photographed in them. They were moved to a spot beside the courthouse in 1984 despite minimal evidence that stocks were located there in colonial times. The tree on the left is still standing.

88

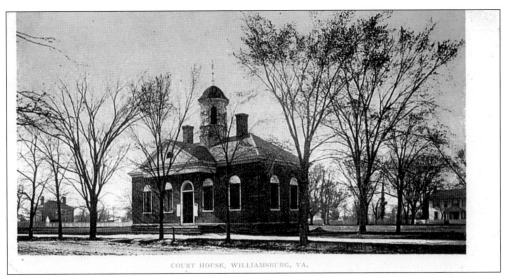

COURT HOUSE, WILLIAMSBURG, VA.

THE COURTHOUSE, C. 1902. Construction on the Courthouse began in 1770 on Duke of Gloucester Street on what has come to be called Courthouse Green. The Revolutionary War prevented four columns from being delivered from England and installed under the portico. Otherwise, the Courthouse is considered a perfect example of well-proportioned Georgian architecture. The building was used as a hospital for Confederate wounded after the Battle of Williamsburg in 1862. In the background can be seen the Wythe House (left) and the Grissell-Hay Lodging House (right).

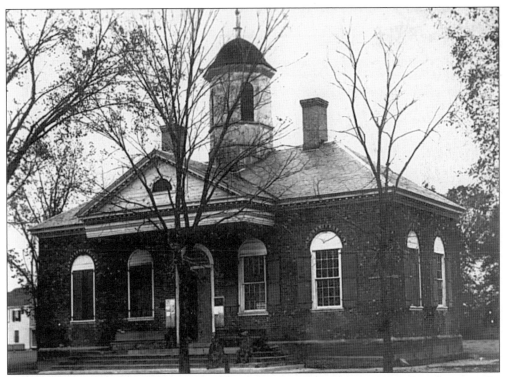

THE COURTHOUSE, C. 1905–1906. This is a rare "real photo" of the Courthouse of 1770. The sign in the window appears to be an advertisement for an insurance company.

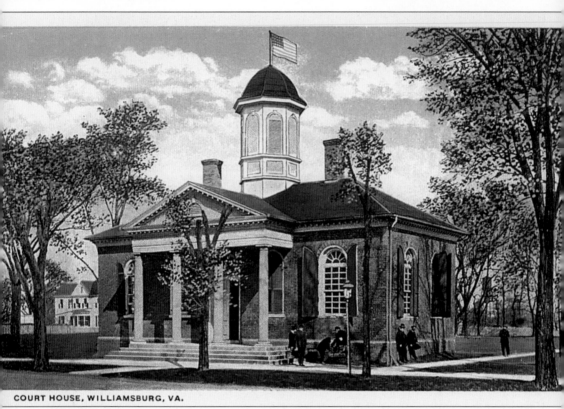

COURT HOUSE, WILLIAMSBURG, VA.

THE COURTHOUSE, C. 1916. The courthouse finally received its columns in 1911 after an April 6 fire gutted the building, only to have them removed again in 1932 in order to be faithful to the building's colonial appearance. In 1931, ownership of the Courthouse passed to the Restoration, which opened it as an archaeological museum the next year. During the Courthouse's tenure as a museum, artifacts from local excavations and images of pre-restoration Williamsburg were displayed here. It is now an exhibition building.

BRUTON PARISH CHURCH AND CHURCHYARD, C. 1902–1907. Established as an Anglican church, Bruton Parish Church is the oldest Episcopal church in continuous use in America, and is one of the most recognizable buildings in Williamsburg. It replaced a smaller church that stood nearby in the present churchyard. Construction on the church began in 1712 and was completed by about 1715, although further work extended the eastern end by 22 feet in 1752. The churchyard of Bruton Parish Church contains the tombs of many prominent figures and several casualties of the Civil War. The large white monument toward the center is that of Elizabeth and David Bray (d. 1734 and 1731).

BRUTON PARISH CHURCH, C. 1937. This is Bruton Parish Church from the Palace Green. The wall surrounding Bruton Parish Church was completed in 1754, and the tower was added in 1769. Past the church on the right is the Bowden-Armistead House.

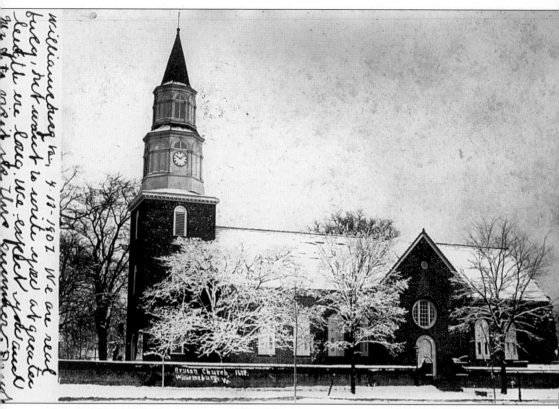

BRUTON PARISH CHURCH, C. EARLY 1907. This rare postcard of Bruton Parish Church under a thin layer of snow was produced by J. Paris Goodbar, who moved from Westerville, Ohio, in January 1907 and set up a photography business. The tower clock was taken from the Courthouse in 1840, and originally may have come from the second Capitol building. The clock was given to Colonial Williamsburg in 1931 and placed in the cupola of the Capitol, where it resided until April 2002. Goodbar's wife, Elsie, wrote the message on the left of the card to her friend Mrs. C.J. Showalter of Westerville, Ohio.

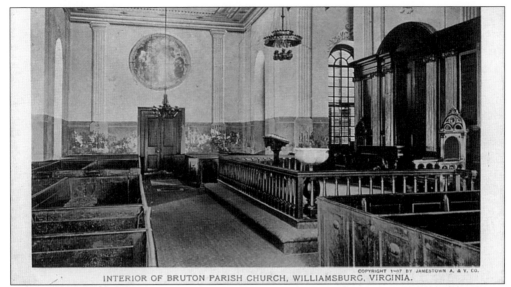

INTERIOR OF BRUTON PARISH CHURCH, WILLIAMSBURG, VIRGINIA.

BRUTON PARISH CHURCH INTERIOR, *C.* 1907. Visible here is the southern transept and the altar (right), which had been moved to the western end of the nave in 1838. The partition wall was removed and the altar returned to the east end in the restoration of 1905–1907 carried out under the leadership of Rev. W.A.R. Goodwin. Visible near the altar is what was popularly believed to have been Pocahontas's baptismal font, brought from the church at Jamestown. Transept galleries, present as early as 1721, have since been reconstructed. The south gallery was intended for the Speaker of the House of Burgesses and William and Mary faculty, the north for slaves.

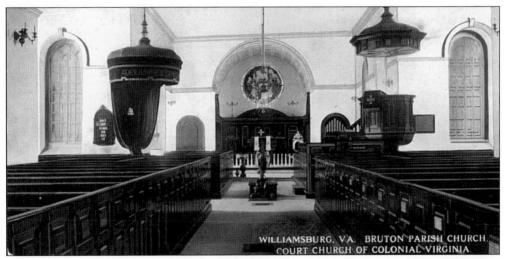

WILLIAMSBURG, VA. BRUTON PARISH CHURCH.
COURT CHURCH OF COLONIAL VIRGINIA.

BRUTON PARISH CHURCH INTERIOR, *C.* 1907–1910. Here, the altar is pictured soon after it was returned to the east end of the church in 1907. The canopied pew to the north (left) was patterned after the style of those used by colonial governors, one of whom, Spotswood, was responsible for the construction of the church. The canopy was taken down in 1939. The elevated pulpit to the south (right) has a wooden soundboard to amplify sermons. Visible in the center is the lectern presented by President Theodore Roosevelt on October 5, 1907 to commemorate the tercentenary of the landing of British colonists (and thus Anglicans) at Jamestown. It holds the bible presented on the same day by King Edward VII.

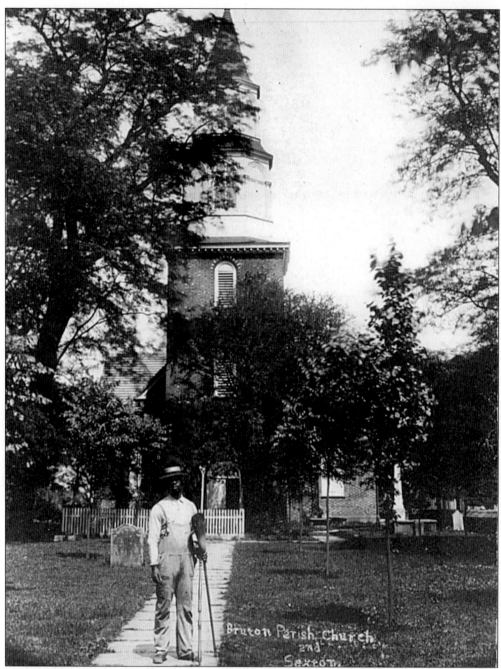

SEXTON OF BRUTON PARISH CHURCH, C. 1906. This man is almost certainly William Galt, sexton of Bruton Parish Church in the early 20th century during Dr. Goodwin's first tenure as rector. Galt was a sexton for 30 years, but also worked as an informal tour guide for interested travelers. At least three postcards feature him. Goodwin was fond of telling the story of how Galt, always eager to expand his knowledge of the churchyard's occupants, once went to Rev. Edmund Ruffin Jones asking where Hamlet's ancestors lay buried. Galt had been reading Goodwin's first book, which contained lines from a poem by Thomas Gray: "Each in his narrow cell forever laid, the rude forefathers of the hamlet sleep."

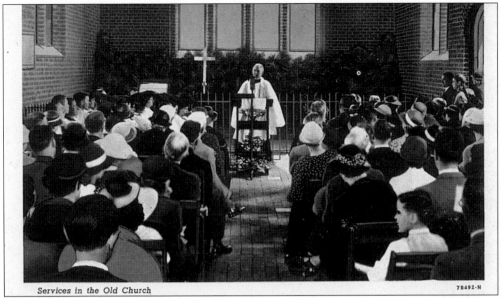

Services in the Old Church

7B492-N

REV. W.A.R. GOODWIN, C. 1930s. Rev. Dr. W.A.R. Goodwin was largely responsible for the Restoration of Williamsburg. Goodwin was rector of Bruton Parish Church from 1903 to 1909 and again from 1926 to 1938. He was also professor of biblical literature and religious education at William and Mary starting in 1923, and led the William and Mary endowment campaign until 1935. Here Goodwin is pictured holding services in the restored Jamestown Church. This postcard was printed in 1947, eight years after Goodwin's death.

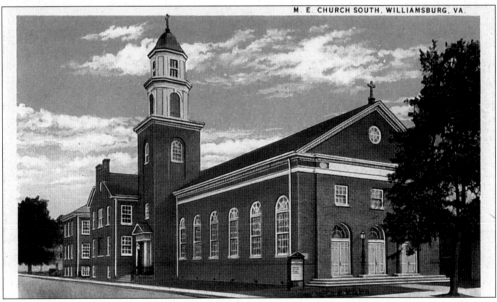

M. E. CHURCH SOUTH, WILLIAMSBURG, VA.

WILLIAMSBURG METHODIST CHURCH, C. 1928. This church was built at the intersection of North Boundary Street and Duke of Gloucester Street in 1926 to replace the smaller church facing Market Square. This church was demolished in 1981. During World War II, students and local citizens watched for enemy aircraft from the unheated 65-foot tower. The site of the church is now a vacant lot, although there are plans to build upon it.

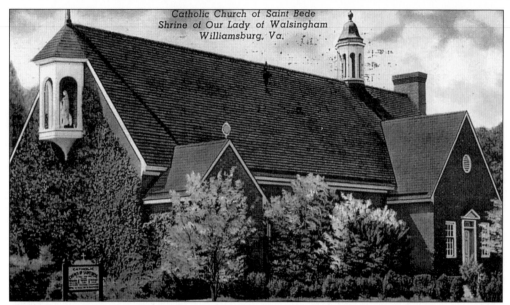

CATHOLIC CHURCH OF ST. BEDE, C. 1954. St. Bede's is located at 500 Richmond Road, at the intersection with Harrison Avenue. When St. Bede's was built in 1932, there were only a few Catholic families in Williamsburg. It was built mainly to meet the needs of Catholic students and, increasingly, tourists. The bricks used in the construction of the church were hand-made by Paul Griesenauer, a parishioner. In 1951, a "Memory Walk," made up of stones from each of the 48 states, was laid between the church and Richmond Road to honor the many men and women who had lost their lives defending their country.

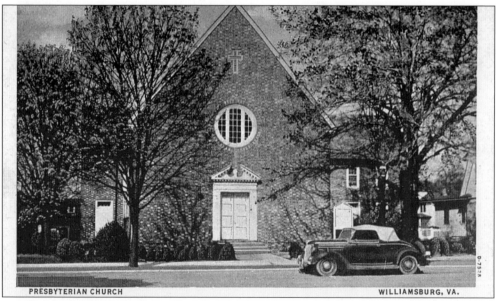

WILLIAMSBURG PRESBYTERIAN CHURCH, C. 1944. A Presbyterian church was formally organized in Williamsburg in 1860. A building was eventually constructed in the 1880s at the northwest corner of Prince George Street and Palace Street (now the site of the reconstructed Elkanah Deane House). It was demolished in 1930, and this new church at 215 Richmond Road opened in March 1931.

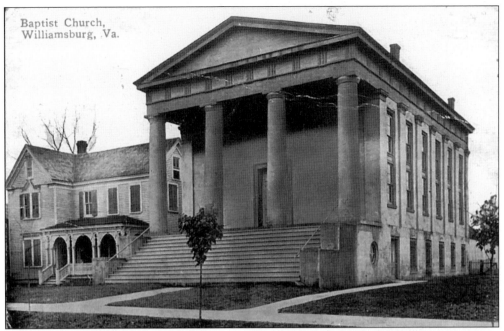

Baptist Church, Williamsburg, .Va.

WILLIAMSBURG BAPTIST CHURCH, C. 1911.
The Williamsburg Baptist Church (formerly Zion Baptist Church) was built in 1855–1856 near the Powder Magazine in Market Square, using bricks from the Magazine's original surrounding wall in its foundation. The church's first minister, the Reverend Scervant Jones, had led the congregation for 25 years in the Powder Magazine itself before construction of the new church. The Baptist church was used as a hospital during the Civil War, during which Confederate dead were temporarily laid to rest outside the church's west wall. For three years after the war, the church was used as a school by the Freedmen's Bureau. The church was torn down in 1934.

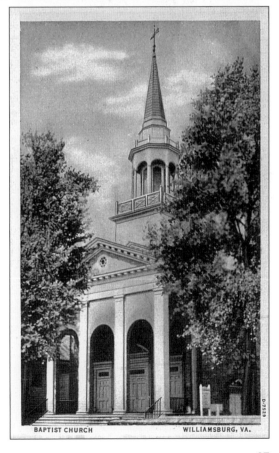

BAPTIST CHURCH WILLIAMSBURG, VA.

WILLIAMSBURG BAPTIST CHURCH, C. 1944.
When the Baptist church on Duke of Gloucester Street (above) was demolished in 1934, the congregation moved to this new building at 227 Richmond Road, across the street from William and Mary's campus.

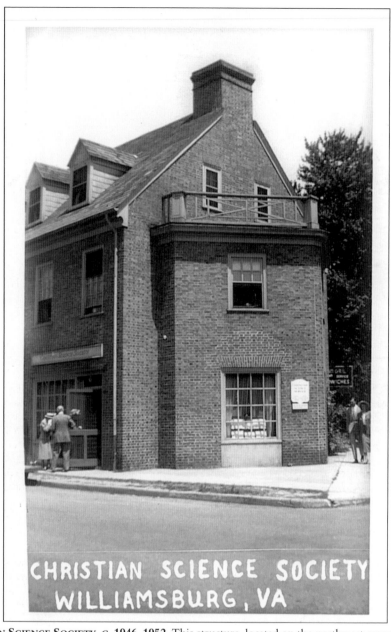

CHRISTIAN SCIENCE SOCIETY, C. 1946–1952. This structure, located on the northwest corner of North Boundary and Prince George Streets, was the second location of the new Imperial Theatre beginning in 1932. Until the construction of Merchants Square, the old Imperial had been located about where the Kimball Theatre is now. The new Imperial was a joint venture of Angelo Costas, George Stath, and George Rollo. The Christian Science Society was headquartered here from 1936 to 1952, and the First Church of Christ, Scientist was headquartered here from 1952 to 1957. Around the corner to the right can be seen George Callas' Indian Grill, which he opened after returning from Naval duty in the Second World War. In 1966, the West End Market moved into this building from across the street in the Hitchens Building. In the 1980s it housed the Athletic Attic. It is now home to several businesses and an art gallery.

Seven

PRESERVING THE PAST

Historically-minded people were thinking about restoration long before Colonial Williamsburg was planned. Active preservation efforts in Williamsburg can be traced to 1884 with the formation of the Catharine Memorial Society, composed mainly of children and devoted primarily to maintaining the tombstones in Bruton Parish Churchyard. The APVA, founded in Williamsburg by Cynthia Beverly Tucker Coleman and Mary Jeffrey Galt in 1889, was formed to preserve Virginia's historic structures from destruction. Among its first projects were the preservation of the rapidly deteriorating Powder Magazine, the Capitol site, and the icehouse behind the Governor's Palace. Today the APVA continues to purchase, restore, and share Virginia's historically important structures.

The struggle to preserve what remained and to recreate was lost was continued by the Colonial Williamsburg Foundation. When Rockefeller and Goodwin forged their unlikely alliance, the events set in motion would change historic preservation forever. The painstaking research undertaken by Colonial Williamsburg set standards with the organization's guiding principles of preservation and authenticity. In support of these fundamental principles, artificial aging of materials was discouraged, as was destruction when preservation was feasible. The result was a city-sized shrine to patriotic ideals that has since evolved into an organization dedicated to preserving and promoting U.S. history.

Throughout the early 1930s, colonial interpreters had been limited to coach drivers, cooks, and hostesses. The 1930s and 1940s saw the resurrection of colonial crafts, such as wigmaking, spinning, blacksmithing, metalwork, and printing. The crafts program had the added bonus of producing handmade goods that could be sold to tourists. This program, intended to attract and educate visitors, marked a transition between Colonial Williamsburg's original purpose as an endowed patriotic shrine and its new goal of becoming an organization capable of sustaining itself financially. Colonial crafts remain a major part of the Colonial Williamsburg experience and serve to heighten the city's historical ambience.

Of course, the illusion Colonial Williamsburg sought to create was not, and cannot ever be, complete. Soon after Colonial Williamsburg had mostly completed its first wave of restoration, one writer noted that "there is inevitably a disconcerting newness about all this antiquity that suggests the snowy glitter of grandpa's false teeth." Hidden steel beams were used to keep fragile structures erect. Trees were allowed to remain and more were planted, despite the fire-wary colonial customs. Waste bins and fire hydrants are discretely hidden from view behind boxwood hedges. Soda machines and other modern conveniences are present but not obvious. Despite these concessions to modernity, Colonial Williamsburg has done much to restore Williamsburg to its former glory, preserve relics of the past, and educate America about its own beginnings. It is not difficult to suppress the present and immerse oneself in the past when walking down Duke of Gloucester Street (that is, were it not for camera-toting, bicycle-riding fellow tourists!).

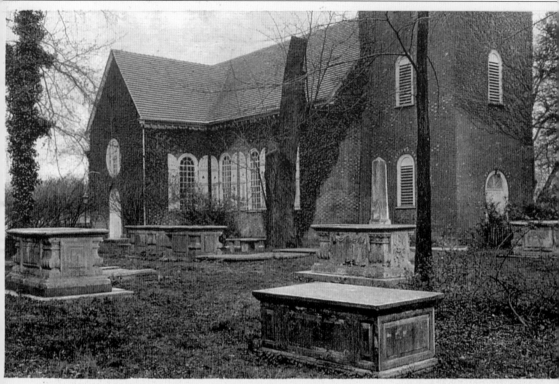

BRUTON PARISH CHURCH AND CHURCHYARD, C. 1929. The beginnings of preservation efforts in Williamsburg can be traced to 1884 with the formation of the Catharine Memorial Society, so named because it was formed in memory of Catharine Brooke Coleman, the daughter of Cynthia Beverly Tucker Coleman, who was later to co-found the APVA. Among other activities, the society raised funds to provide repair and upkeep of memorials in Bruton Parish Churchyard. Tombs here date as early as 1678. In the foreground is the tomb of Ann Frank (d. 1759). Other prominent tombs, from left to right, are those of David and Judith Bray (d. 1717 and 1720), father and son James and Matthew Whaley (d. 1701 and 1705), Elizabeth Page (d. 1702), Gov. Edward Nott (d. 1706), and Thomas and Margaret Hornsby (d. 1772 and 1770). The obelisk near the church is a memorial to Col. John Page (d. 1692).

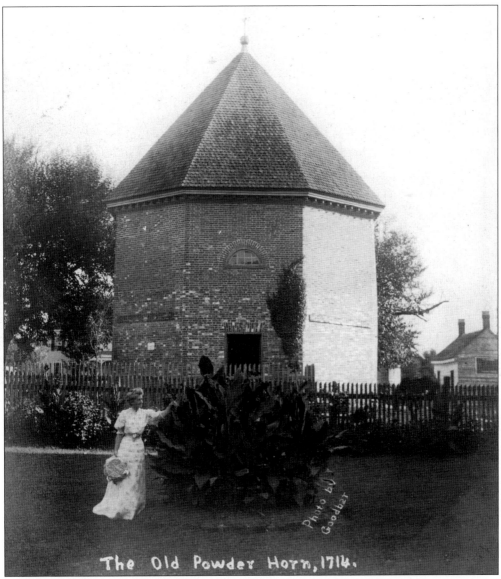

The Old Powder Horn, 1714.

THE POWDER MAGAZINE, C. 1907. This postcard of the north side of the Powder Magazine was printed by local photographer J. Paris Goodbar. Admiring the canna lilies is Virginia Braithwaite Haughwout (Miss Braithwaite at the time), hostess of the "Powder Horn" for the APVA. At the time, the historic structure was being used as a local history museum. "Miss Jenny" was passionately devoted to Williamsburg and its history. By the 1940s she controlled a good deal of land in the historic area of Williamsburg, and steadfastly refused to sell to the Williamsburg Holding Corporation when plans were enacted to restore Williamsburg to its colonial appearance. She founded the Bucktrout-Braithwaite Memorial Foundation in 1954, three years before her death, to fund Episcopal education, preserve family-owned properties, and promote democratic principles. The foundation controls several properties in the historic area, including Wetherburn's Tavern (which Haughwout operated as Richard Bland Tavern), Providence Hall, a Revolutionary War–era graveyard, lots between Duke of Gloucester Street and Nicholson Street containing the reconstructed Printing Press, and some other lots in town. (Postcard courtesy of Swem Library, College of William and Mary.)

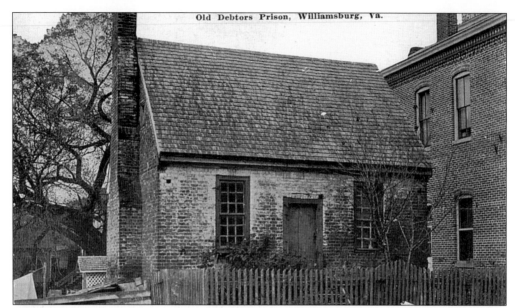

Old Debtors Prison, Williamsburg, Va.

GREENHOW BRICK OFFICE, *C.* **1906.** Built *c.* 1744, this building on the west side of Market Square served as an office for merchant John Greenhow and possibly a customhouse in 1764. Local tradition says it was once a debtor's prison, but no documentation substantiates that theory. The little building was purchased in 1903 by preservationist Mary Galt. In 1906, the "Debtor's Prison" was restored, making it one of the earliest structures in Williamsburg restored purely for the sake of historical preservation. It served as the local office for the Daughters of the American Revolution in the 1930s. This photograph was likely taken in 1906 by local printer James H. Stone, although this postcard was produced years later.

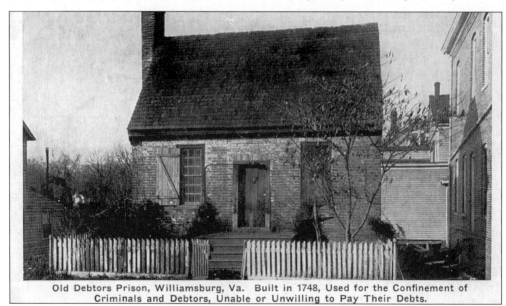

Old Debtors Prison, Williamsburg, Va. Built in 1748, Used for the Confinement of Criminals and Debtors, Unable or Unwilling to Pay Their Debts.

GREENHOW BRICK OFFICE, *C.* **1929.** The office was sold to the Restoration in 1946. Restoration in 1948 involved raising the door to its original height and rebuilding the two dormer windows the building once bore. To the north (right) is the First National Bank (Dirickson Bank Hall), demolished in 1932 to make way for the reconstructed Greenhow Tenement fronting Duke of Gloucester Street.

THE GARDENS OF THE GOVERNOR'S PALACE, *c.* **1935.** These gardens were painstakingly reconstructed under the leadership of landscape architect Arthur Shurcliff. The gardens include pleached arbors, geometrically arranged boxwood, a bowling green, a decorative pond, a Revolutionary War cemetery, and an English holly maze patterned after one at Hampton Court. (A William and Mary tradition is to sneak into the garden's holly maze at night, run through it, and escape before detection). The hill in the distance is the site of what was popularly known as Lord Dunmore's Cave or Lord Dunmore's Wine-cellar, conjectured (incorrectly) to have been connected to the Palace through an underground tunnel and prepared as a means of escape from angry colonists. Today it is more accurately known as the Palace Ice House, and the hill above it as The Mount.

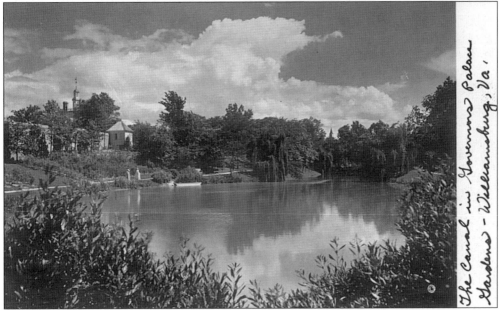

THE GOVERNOR'S PALACE CANAL, *c.* **1935.** Rebuilding a dam restored this body of water adjacent to the gardens of the Governor's Palace. It consists of a "canal" at the southern end attached to a pond at the north. Fish were likely raised here for local consumption, making the canal as useful as it was aesthetic. The gardens descend in terraces to the water.

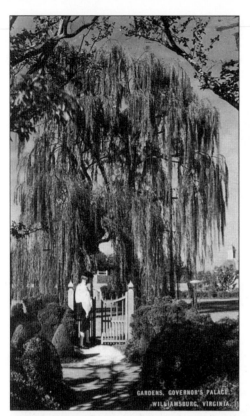

GARDENS, GOVERNOR'S PALACE,
WILLIAMSBURG, VIRGINIA.

GARDENS OF THE GOVERNOR'S PALACE, *C.* 1947.
During an archaeological survey, a Revolutionary
War–era burial ground containing as many as 158
graves, probably American, was unearthed in part of
the Palace gardens. The occupants probably died
from sickness rather than from direct injury—the
Palace was used as a hospital during the Yorktown
campaign in 1781.

GARDENS OF THE GOVERNOR'S PALACE, *C.* 1935.
Only plants known to be grown in colonial gardens,
including both native plants and exotic imports,
were used in the reconstruction of the Governor's
Palace Gardens. The one-story ballroom and
supper room were added to the rear of the original
Governor's Palace *c.* 1752. Like the two postcards
on the previous page, this photograph was taken
by F.S. Lincoln, a photographer employed by
Colonial Williamsburg.

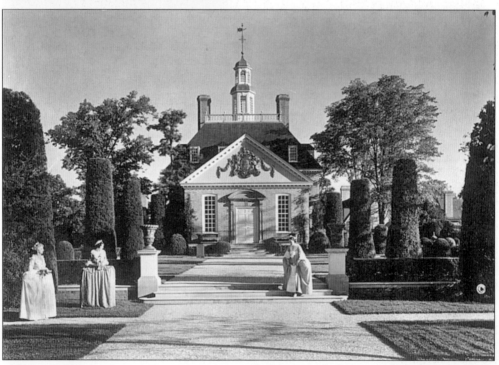

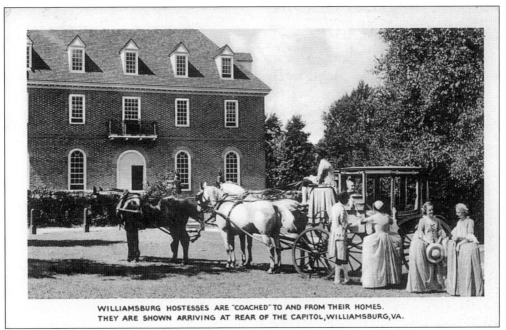

WILLIAMSBURG HOSTESSES ARE "COACHED" TO AND FROM THEIR HOMES.
THEY ARE SHOWN ARRIVING AT REAR OF THE CAPITOL, WILLIAMSBURG, VA.

HOSTESSES ARRIVING AT WORK, C. 1941. Before 1942, the coaches seen on streets of the historic area were used mainly to transport hostesses (tour guides) to and from work and to deliver mail.

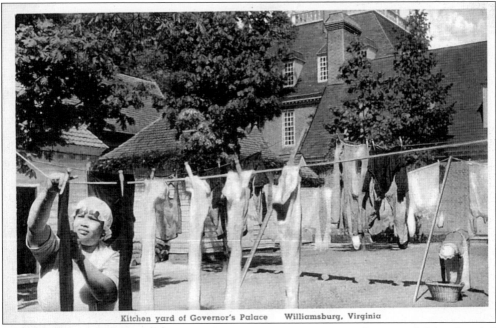

Kitchen yard of Governor's Palace Williamsburg, Virginia

KITCHEN YARD OF THE GOVERNOR'S PALACE, C. 1935. The buildings in the postcard above, from left to right, are the smokehouse, the salthouse, and the western advance building, which was used as a guard house for the Governor's Palace. Visible behind the smokehouse and salthouse is the roof of the Palace's laundry, and behind the guard house is the Palace itself. Here a colonial interpreter hangs hostesses' costumes out to dry.

105

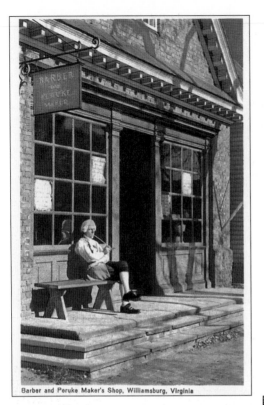

Barber and Peruke Maker's Shop, Williamsburg, Virginia

THE PRENTIS STORE, *C.* 1941. Williamsburg's oldest store has seen many uses in its long history. It was occupied by the Prentis and Co. mercantile firm from its construction in 1739–1740 until at least the Revolutionary War. Insurance maps indicate that it served as a butcher's shop in 1904. It was purchased by Christine H. Henderson in 1912 and served as a barber and dry cleaning service until 1921, when it was converted to an automotive service station. This *c.* 1949 postcard uses a photograph likely taken *c.* 1941.

THE PRENTIS STORE, *C.* 1951. Colonial Williamsburg restored this building in 1929 as Dr. Archibald Blair's Apothecary Shop, which it remained until *c.* 1940. It served as the Barber and Peruke Maker's Shop from *c.* 1941 to *c.* 1950 and afterwards as the Printing Office. In 1972, it underwent major renovations as a result of new archaeological findings and resumed its colonial identity as the Prentis Store. In the latest renovation, the front windows and the floor level were raised, a porch was added, and a cellar entrance was installed at the spot depicted at the lower left of this postcard. The man standing in the doorway is August Klapper, master printer of Colonial Williamsburg.

Printing Office
Williamsburg, Va.

Ayscough Shop, Williamsburg, Virginia

THE AYSCOUGH SHOP, C. 1941. The Ayscough Shop was located due south of the Capitol, on Francis Street. Beginning in 1936, the Ayscough Shop was used to demonstrate the colonial trade of cabinetmaking. It was converted into a gunsmith shop *c.* 1970.

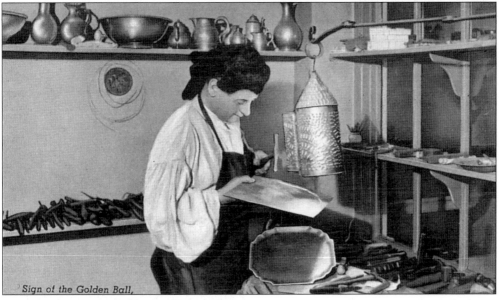

Sign of the Golden Ball,

THE SIGN OF THE GOLDEN BALL, C. 1942. This is the interior of the Sign of the Golden Ball when it was located in what is now the Margaret Hunter Shop, a millinery. Before its restoration, this building was W.T. Kinnamon's Garage. "Captain" Kinnamon moved his business to Richmond Road after selling to the Restoration, where he (and subsequently his son, Wilton) operated the business for many years. Around the time of the American Revolution, however, the building was operated by George Gilmer as an apothecary shop. The building served briefly as a grocery before becoming the Sign of the Golden Ball, home to Colonial Williamsburg's pewter and silversmith. The individual in this postcard was Max Rieg, a master silversmith for Colonial Williamsburg.

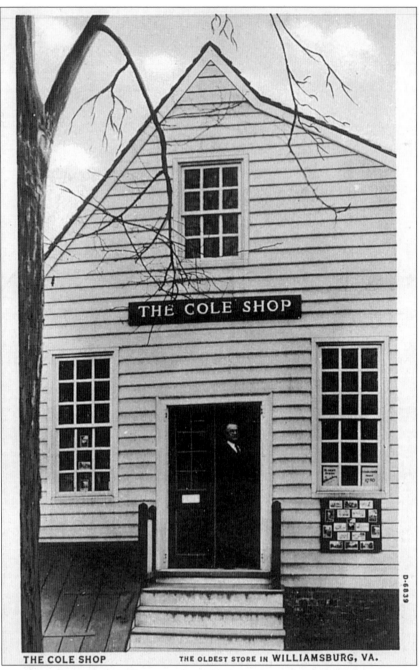

THE COLE SHOP THE OLDEST STORE IN WILLIAMSBURG, VA.

The Taliaferro-Cole Shop, c. 1942. The Taliaferro-Cole Shop (or, more familiarly, the Cole Shop) dates back to at least 1782. After its restoration in 1940, it served for years as a popular book and print shop, a cooper shop, and later as a harness maker and saddler shop. Note the postcards advertised on the bulletin board under the window. Many postcards were sold here in the early 20th century by proprietor Henry Dennison "Den" Cole. The Pulaski Club, which has met regularly in front of the shop since time immemorial, may be the nation's oldest social organization for men. The man in the doorway is likely proprietor William C. Ewing.

108

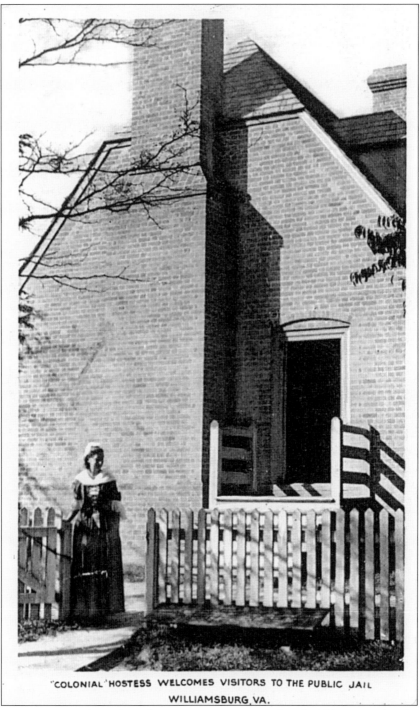

"COLONIAL HOSTESS WELCOMES VISITORS TO THE PUBLIC JAIL
WILLIAMSBURG, VA.

THE PUBLIC GAOL, C. 1941. This rather incongruous picture of a colonial hostess welcoming visitors into a jailhouse illustrates one of the problems associated with historical interpretation. Maintaining historical accuracy is often at odds with the need to make Colonial Williamsburg attractions appealing to tourists. Balancing these sometimes conflicting goals is an art form that has taken decades to master.

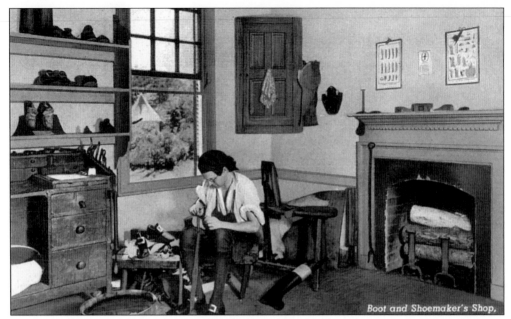

BOOT AND SHOEMAKER'S SHOP, *c.* **1942.** The Boot and Shoemaker's Shop has been located in a small building between the Greenhow Tenement and the John Greenhow Store since about 1940. A colonial shoemaker could turn out perhaps one pair of shoes per day.

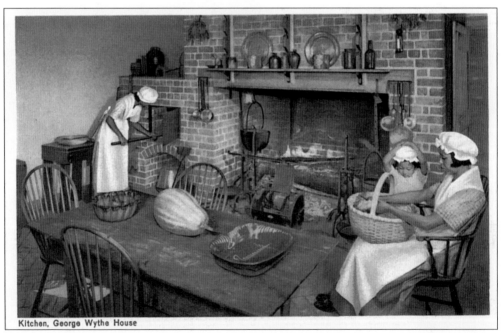

THE KITCHEN OF THE WYTHE HOUSE, *c.* **1946.** One challenging aspect of interpreting the past is to do so as accurately and faithfully as possible, yet in a way that does not offend modern Americans of any ethnicity. James Payne and his family lived in the Wythe House and portrayed a family of slaves from 1939 to 1941, until his daughters were old enough to realize the deeper significance of how they earned their living. This postcard was made from a *c.* 1941 photograph.

110

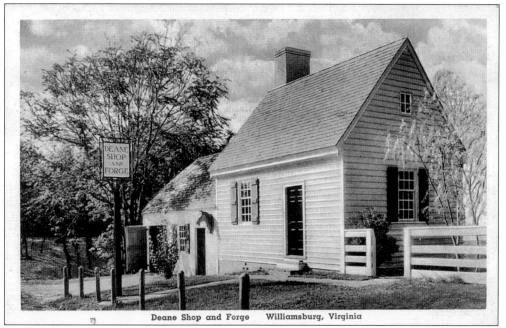

Deane Shop and Forge Williamsburg, Virginia

THE DEANE SHOP AND FORGE, C. 1939. These are the reconstructed shop and forge associated with Elkanah Deane's coach construction business in the 1770s, located on Prince George Street just east of Nassau Street.

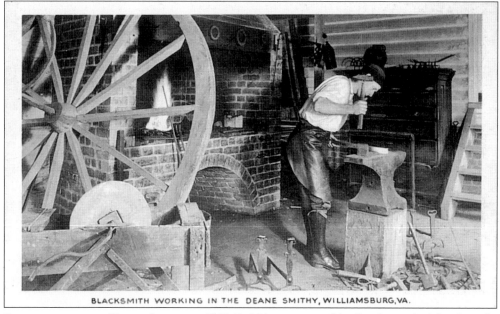

BLACKSMITH WORKING IN THE DEANE SMITHY, WILLIAMSBURG, VA.

BLACKSMITH AT THE DEANE SMITHY, C. 1941. Smithing was one of the first three colonial trades to be practiced and demonstrated at Colonial Williamsburg beginning in 1936. The Deane Smithy was an operating blacksmith shop until the 1980s, when the blacksmith program was relocated to the reconstructed Anderson Forges just off Duke of Gloucester Street behind the James Anderson House. The Deane Smithy is now interpreted as a harness, carriage maker, and wheelwright shop.

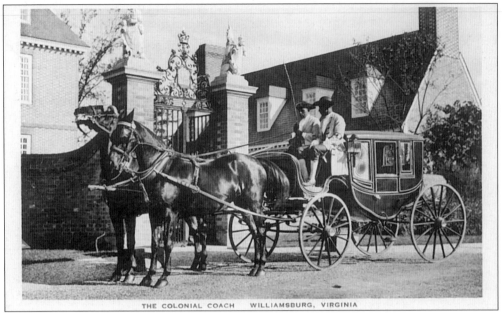

THE COLONIAL COACH WILLIAMSBURG, VIRGINIA

COLONIAL COACH, C. 1937. This is the Carroll Coach in front of the gates of the Governor's Palace, *c.* 1937. Several carriages began circulating through the historic area *c.* 1935. Beginning in 1942, tourists could purchase rides for 50¢. This town coach, probably made *c.* 1890 by James Cunningham, Son, & Co. of Rochester, New York, was restored by Colonial Williamsburg to resemble 18th-century precedents. It was given to the Shelburne Museum in Vermont but has since been resold. The coachman holding the whip is likely Junius Bartlett.

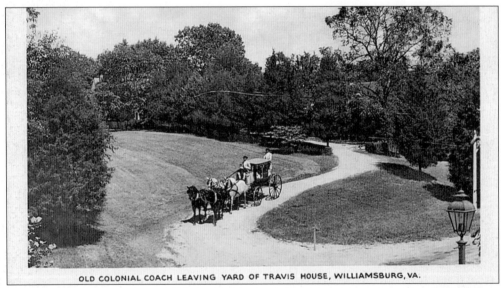

OLD COLONIAL COACH LEAVING YARD OF TRAVIS HOUSE, WILLIAMSBURG, VA.

COLONIAL COACH, C. 1941. Here, the Randolph Coach is about to emerge onto Francis Street from the rear drive of the Travis House at its former location on Duke of Gloucester Street. The green sward stretching from the upper left corner to the lower right is the former King Street, now an extension of Palace Green across Duke of Gloucester Street. King Street was landscaped into nonexistence in 1939 or 1940.

112

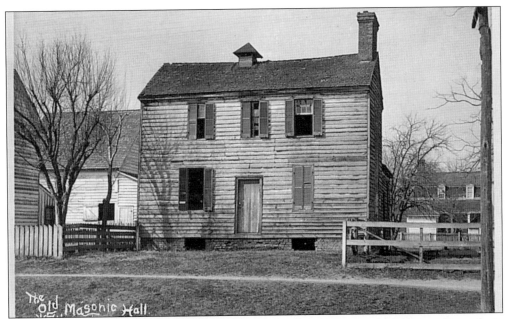

THE OLD MASONIC LODGE, _C._ 1906. This building, erected _c._ 1773, was located near the northeast corner of Queen and Francis Streets. The first Grand Lodge in America was organized in this building in 1778. The building served briefly as a schoolhouse in the early 20th century. There was an attempt to raise funds to preserve the lodge in 1906, but funds were not forthcoming or else the building was too deteriorated. It was torn down in 1910. The old Masonic Lodge is believed to have been the oldest building in the United States used for Masonic purposes.

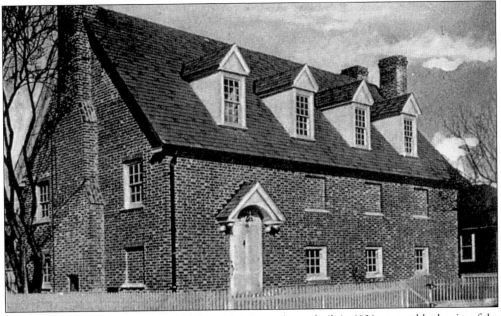

THE NEW MASONIC LODGE, _C._ 1950s. A new brick temple was built in 1931 on roughly the site of the old Masonic Lodge. Bricks from the original structure's foundations were incorporated into the new building's fireplace.

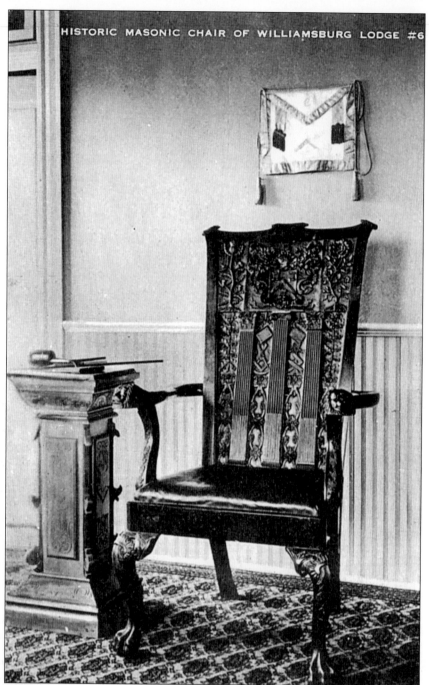

MASONIC MASTER'S CHAIR, *C.* **1952.** This mahogany chair was probably made by local cabinetmaker Anthony Hay *c.* 1765 and was presented to Lodge 6 by Lord Botetourt. The chair is exquisitely executed but is nevertheless based in several respects on an earlier chair of similar design. It has been used by many Masonic Masters, and it is said that it was used in George Washington's Masonic inauguration. The chair is still owned by Lodge 6 but is on long-term loan to Colonial Williamsburg. It currently sits in the DeWitt Wallace Decorative Arts Museum.

Eight

DUKE OF GLOUCESTER STREET

Running down the center of Williamsburg is the city's main east-west thoroughfare, Duke of Gloucester Street, so named for the eldest son of Queen Anne. Duke of Gloucester Street itself was, and still is, a popular subject for postcards. It was called "the most historic avenue in all America" by President Franklin D. Roosevelt in his memorable visit to Williamsburg in 1934. He had good reason to call it that. Some of the most influential, powerful, and colorful people in the nation's history have walked its length from the College of William and Mary to the Capitol. Duke of Gloucester Street is now closed to most automobile traffic in order to maintain an 18th-century atmosphere.

Duke of Gloucester Street began its existence as a winding horse path connecting far-flung estates and plantations. It was perhaps the successor to an even earlier Native-American footpath winding down the ridge between the James and the York. The path entered what would become Williamsburg from north of the Wren Building, roughly where Richmond Road now passes. It wound its way through farmland, passing north of the future site of Bruton Parish Church at one point and south of the future Francis Street at another. When the city of Williamsburg was laid out by Gov. Francis Nicholson in 1699, the path was chosen as the site of the city's main street, cresting the ridge between two militarily and economically strategic rivers. It stretches three quarters of a mile in length, from the College of William and Mary at its western extremity to the Capitol at the east. As late as 1720, Duke of Gloucester Street was still punctuated at intervals by inconvenient ravines. Standing at the Capitol, one could see carriages disappear from view and then reappear as they entered and exited these ravines. Much has been done in the last 300 years to render the street more level, but if a person stands at one end and looks toward the other, slight undulations conforming to the landscape can still be easily discerned.

By the beginning of the 20th century, Williamsburg's primary business section was located near the center of town on Duke of Gloucester Street, with businesses vying for space on the south side of Market Square. With the restoration of Williamsburg to its colonial appearance, many businesses needed to be relocated outside the historic area. Because of a relative lack of information about this part of town in colonial times, the two blocks facing Duke of Gloucester Street between Boundary Street and Henry Street were chosen as the location for a modern shopping area, later to be called Merchants Square. The city has since expanded to include many centers of commerce, but Merchants Square remains almost unchanged since 1930.

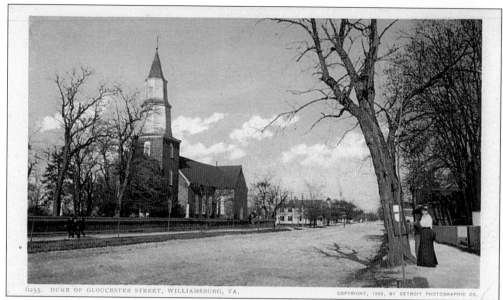

DUKE OF GLOUCESTER STREET, C. 1902. This is a stretch of Duke of Gloucester Street, facing east, from near its intersection with Nassau Street. Pictured here are Bruton Parish Church and the Geddy House. The ladies on the right are reading notices on the Pulaski Club's bulletin board, nailed to a tree in front of the Cole Shop.

DUKE OF GLOUCESTER STREET, C. 1907. This view shows wheel tracks turning from Duke of Gloucester Street onto Jamestown Road at College Corner, the intersection of Jamestown Road, Richmond Road, and Duke of Gloucester Street. The tower of Bruton Parish Church is visible in the distance. (From the Carlton Casey collection, Swem Library, College of William and Mary.)

Duke of Gloucester St., Williamsburg, Va.—

DUKE OF GLOUCESTER STREET, C. 1906. Visible on the right (south) of Duke of Gloucester Street is the Taliaferro-Cole House. The building on the extreme right edge, situated on the southwest corner of Duke of Gloucester Street and Nassau Street, was a jewelry shop. The gas lamps running down the middle of the street were turned off late at night and during full moons.

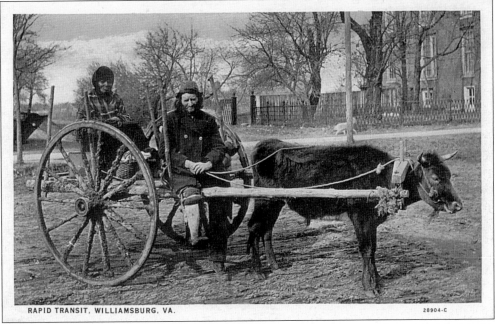

RAPID TRANSIT, WILLIAMSBURG, VA. 28904-C

REV. BENJAMIN ROBINSON, C. 1906. Here, a local clergyman, Rev. Benjamin Robinson, is pictured with a traveling companion on Duke of Gloucester Street. Ox-carts were reliable, if slow, transportation in the often muddy streets and countryside. In the background is the Bowden-Armistead House with its wrought-iron fence. The house, built in 1858, is one of only two 19th-century structures still standing on Duke of Gloucester Street, the other being the eastern brick portion of the Roscow Cole House. The Bowden-Armistead House remains in the Armistead family to this day.

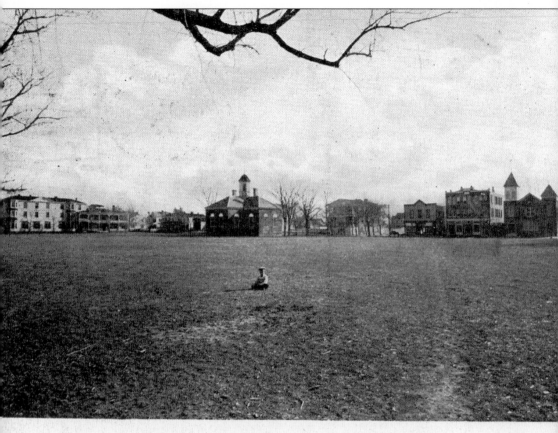

Court House Green, Williamsburg, Va.

COURTHOUSE GREEN, C. 1906. Courthouse Green, on the north side of Duke of Gloucester Street, is part of the original Market Square. It has remained almost completely free of encroaching structures since Williamsburg's establishment in 1699. From left to right are J.B.C. Spencer's Colonial Inn, the Raleigh Hotel (now the restored Market Square Tavern), the Courthouse, Williamsburg Hotel, Spencer's wooden store (Peninsula Garage), the Peninsula Bank, and Williamsburg Methodist Church. In 1917, one writer described Courthouse Green as a "solid golden sheet of buttercups." Buttercups still grow there in profusion today, and their beauty has been remarked upon by many writers. (From the Carlton Casey collection, Swem Library, College of William and Mary.)

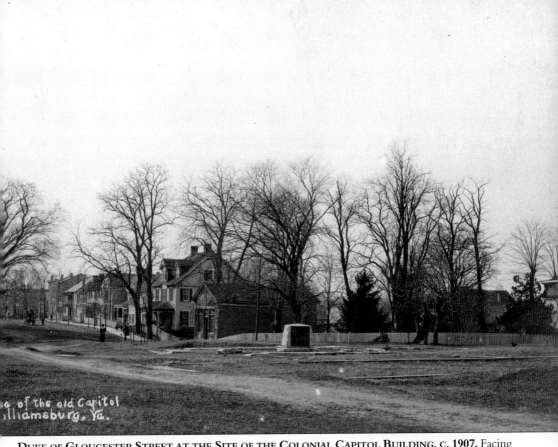

o of the old Capitol
Illiamsburg, Va.

DUKE OF GLOUCESTER STREET AT THE SITE OF THE COLONIAL CAPITOL BUILDING, C. 1907. Facing west down Duke of Gloucester Street in the early 20th century, one would have seen an interesting mix of colonial simplicity, Victorian gingerbread, and more modern structures. The buildings along Duke of Gloucester Street are, from right to left, an unknown structure, the Dora Armistead House, the home of Mr. and Mrs. Maurice E. Donegan, the home of Mr. and Mrs. L. Peyton Little, the home of Mrs. Victoria Lee, the home of Mr. and Mrs. Galba Vaiden (now the restored Alexander Craig House), and the L.W. Lane Store (the site of the Raleigh Tavern). The Dora Armistead House, until recently one of the last remaining 19th-century structures in the historic area, was moved to a site on North Henry Street in 1996. It had been situated on the site of a popular colonial tavern, and its structure even incorporated some of the tavern's materials. Some of the upstairs rooms of the Armistead House were rented to servicemen during World War II. The L.W. Lane Store was situated on the site of the Raleigh Tavern and carried groceries, dry goods, and clothing. Just visible to the right is the colonial Public Records Office, then serving as a private residence for the Jones family. (From the Carlton Casey collection, Swem Library, College of William and Mary.)

DUKE OF GLOUCESTER STREET, LOOKING WEST, C. 1911. The prominent buildings are, from left to right, the Powder Magazine, the Williamsburg Hotel, Bruton Parish Church, the Roscow Cole House, the George Wythe House, and the Courthouse. The sign in the lawn in front of the Powder Magazine

Street Scene, Looking West, Showing Powder Horn, Court House, and Wythe House,
PUB. BY J. H. STONE Williamsburg, Va.

DUKE OF GLOUCESTER STREET, LOOKING WEST, C. 1906. The sidewalks were paved for the first time in the summer of 1905. As late as the 1910s, Duke of Gloucester Street, still unpaved, alternated between being ankle-deep in dust and ankle-deep in mud, depending on the weather. Prominent buildings in this postcard are, from left to right, Williamsburg Baptist Church, the Powder Magazine, the Williamsburg Hotel, the Courthouse, and the Wythe House. (From the Carlton Casey collection, Swem Library, College of William and Mary.)

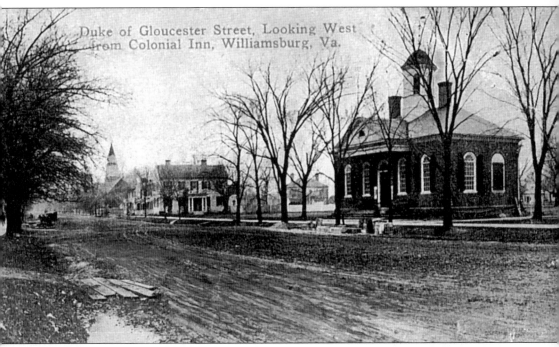

reads "Old Powder Horn [unreadable] Gov. Spottswood." At the time, the Powder Magazine was being used as a museum by the APVA.

DUKE OF GLOUCESTER STREET, LOOKING WEST, C. 1916. From left to right are the Williamsburg Hotel, the Peninsula Garage (Spencer's wooden store), the Peninsula Bank, Williamsburg Methodist Church, and First National Bank. The Williamsburg Hotel (or Hotel Williamsburg) building, erected in 1854, is pictured here after a two-story porch had been added to the front. It served as the Red Circle Club, the District Court Building during the Civil War, and Dr. Baxter Bell's hospital from 1925 to 1930. It was demolished in 1930. Part of the building was used as a prison for a stretch before the Civil War and as a hospital during it. It also may have served as the local Chesapeake and Ohio rail station for two months in 1881 when train tracks were laid down the middle of Duke of Gloucester Street. No passenger car ever ran on these temporary rails (they were deemed too unsound), but the gravel poured for the tracks provided ammunition for slingshots for years to come.

DUKE OF GLOUCESTER STREET, LOOKING EAST, C. 1916. From left to right are the Baptist Church (with columns), Williamsburg Hotel, the Peninsula Garage, the Peninsula Bank, Williamsburg Methodist Church, First National Bank, the Williamsburg Drug Co., and a sign that says "Mercer." Duke of Gloucester Street would not be paved until 1918. The Methodist Church, built in 1842, served as Williamsburg's post office from 1926 until its demolition in 1933. The Williamsburg Drug Co. dates to the 19th century. It relocated to Merchants Square in 1935 (where The Trellis is now located) and to the corner of Duke of Gloucester Street and South Boundary Street in 1978. Its lease ended in January 2002, and it has since relocated well outside of the historic area to Merrimac Trail.

Duke of Gloucester Street. Williamsburg, Va.

DUKE OF GLOUCESTER STREET, C. 1917. This is Duke of Gloucester Street, looking west, probably just before the median was installed. The Courthouse is visible on the left. The other buildings are, from right to left, The Williamsburg Drug Co., First National Bank, and Williamsburg Methodist Church. (From the Carlton Casey collection, Swem Library, College of William and Mary.)

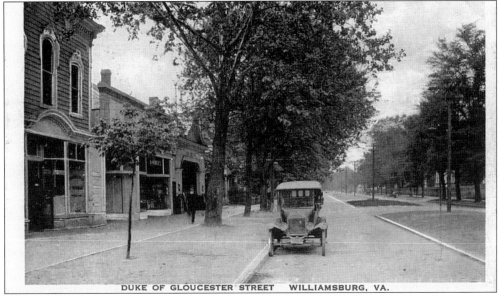

DUKE OF GLOUCESTER STREET WILLIAMSBURG, VA.

DUKE OF GLOUCESTER STREET, C. 1926. Looking west from the curb in front of First National Bank, one could see utility poles stretching the length of Duke of Gloucester Street. The building on the far left is the Williamsburg Drug Co., the store which commissioned and sold this postcard and many others. Old maps identify the next two structures on the left as a confectionery and a clothing store. Just beyond these is the Palace Theatre. The Palace Theatre was opened in 1913 opposite Palace Green by B.F. Wolfe, who sold it for $12,000 in 1920. Dr. Goodwin bought it with the authorization of John D. Rockefeller Jr. for $7,000 on July 7, 1927. It was presumably demolished soon thereafter.

Duke of Gloucester Street, Williamsburg, Va., named in 1705 in honor of Queen Anne's oldest son. Williamsburg became the seat of government of the colony in 1699 and continued as such until 1780. Here many of the most important events of early American history were enacted. Many of the buildings of colonial days are still standing. 59891

DUKE OF GLOUCESTER STREET, C. 1928. Duke of Gloucester Street was paved, with a median, in 1918. The view above was obscured by telephone poles for three quarters of a mile. An artist employed by the Curt Teich Company of Chicago altered the original photograph to eliminate most of the poles, although some are still partially visible in the distance. The poles would be removed in reality, and the wires buried underground, in 1932. On the left (north) side of the street is J.B.C. Spencer's Colonial Hotel. On the right (from right to left) are the gas pump of the Peninsula Garage, Hotel Williamsburg, and the 1856 Williamsburg Baptist Church.

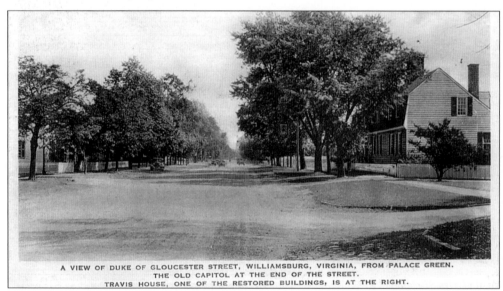

A VIEW OF DUKE OF GLOUCESTER STREET, WILLIAMSBURG, VIRGINIA, FROM PALACE GREEN.
THE OLD CAPITOL AT THE END OF THE STREET.
TRAVIS HOUSE, ONE OF THE RESTORED BUILDINGS, IS AT THE RIGHT.

DUKE OF GLOUCESTER STREET, C. 1937. With the Restoration, electric wires and telephone lines were buried under Duke of Gloucester Street. The street was repaved and covered with a thin layer of dirt to look as it had in colonial days. To the left (north) in this postcard is the Geddy House, and to the right is the Travis House at its former location across from Palace Green. At the lower right corner is the northern terminus of the now-vanished King Street.

New Shop Buildings Williamsburg, Virginia

MERCHANTS SQUARE, C. 1940. In returning the city to its colonial appearance, many businesses were relocated "downtown" to the western end of Duke of Gloucester Street while formerly open spaces and village greens were reclaimed from the teeth of progress. Here, on the southwest corner of Henry and Duke of Gloucester Streets, was the local A&P grocery store, now the location of Craft House. To its right were a barber shop and a sporting goods store, later The Pastry Shop bakery and Rose's Five-and-Dime, respectively. Merchants Square was an early prototype for the modern American shopping center.

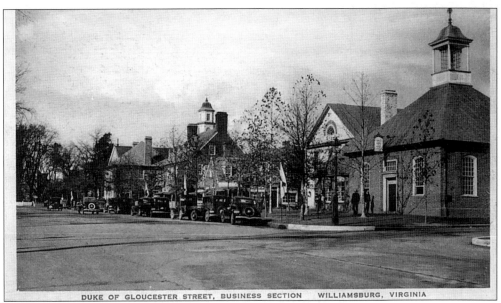

DUKE OF GLOUCESTER STREET, BUSINESS SECTION WILLIAMSBURG, VIRGINIA

MERCHANTS SQUARE, C. 1936. Another view looking northwest from the intersection of Henry and Duke of Gloucester Streets, this card shows from right to left the Peninsula Bank and Trust Co. (on site of College Pharmacy), The Williamsburg Drug Co. (now The Trellis), the U.S. Post Office (now the Christmas Shop), Pender's grocery store (now the Toymaker of Williamsburg), the Colonial Restaurant, the Stringfellow Building (now Binns Fashion Shop), and Williamsburg Methodist Church. In 1973, Duke of Gloucester Street was permanently closed to traffic from this intersection to College Corner.

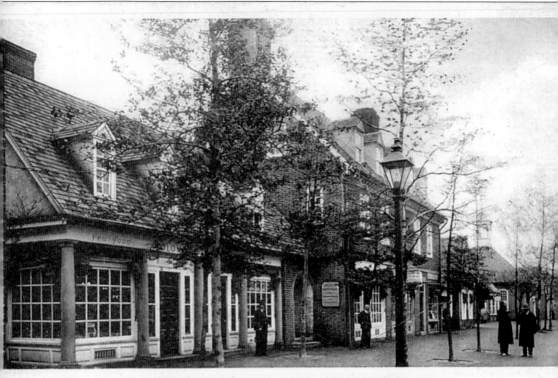

DUKE OF GLOUCESTER STREET, WILLIAMSBURG, VA.

MERCHANTS SQUARE, C. 1940s. This is the view looking east from the north side of Duke of Gloucester Street in Merchants Square. Visible in the foreground is the Colonial Restaurant. The doors to the right were entrances to a women's clothing store and Frazier-Graves men's clothing store in later years. Until recently, the large central structure contained Rizzoli Bookstore. The building is today home to R. Bryant, Ltd., Bella Lingerie, and The Precious Gem.

SELECTED BIBLIOGRAPHY

Belvin, Ed. *Growing Up in Williamsburg: From the Depression to Pearl Harbor*. Williamsburg: The Virginia Gazette, Inc, 1981.

Carson, Jane D. *We Were There: Descriptions of Williamsburg, 1699–1859*. Williamsburg: Colonial Williamsburg Foundation, 1965.

Chamberlain, Samuel. *Behold Williamsburg: A Pictorial Tour of Virginia's Colonial Capital*. New York: Hastings House, Publishers, 1947.

The College of William and Mary (1899–present). *Colonial Echo*.

The College of William and Mary (1995). "Vital Facts: A Chronology of the College of William and Mary."

Foster, Mary L. *Colonial Capitals of the Dominion of Virginia*. Lynchburg, VA: J.P. Bell Company, Inc.,1906.

Goodwin, W.A.R. *Bruton Parish Church Restored and its Historic Environment*. Petersburg, VA: The Franklin Press Co., 1907.

Hawthorne, Hildegarde. *Williamsburg Old and New*. New York: D. Appleton-Century Company, 1941.

Hudson, Carson O. Jr. *Civil War Williamsburg*. Williamsburg: The Colonial Williamsburg Foundation, 1997.

Kale, Wilford. *Hark Upon the Gale: An Illustrated History of The College of William and Mary*. Norfolk: The Donning Company, 1985.

Kopper, Philip. *Colonial Williamsburg*. (revised edition) New York: Harry N. Abrams, Inc., 2001.

Maccubbin, Robert P. (Ed.). *Williamsburg, Virginia: A City Before the State*. Richmond: Carter Printing Co., 2000.

McCartney, Martha W. *James City County: Keystone of the Commonwealth*. James City County, VA: The Donning Company Publishers, 1997.

Molineux, Will. *Images of America: Williamsburg*. Charleston, SC: Arcadia Publishing, 2001.

Montgomery, Dennis. *A Link Among the Days*. Richmond: Dietz Press, 1998.

Olmert, Michael, and Coffman, Suzanne E. *Official Guide to Colonial Williamsburg*. Williamsburg: The Colonial Williamsburg Foundation, 1998.

Rouse, Parke Jr. *Cows on the Campus: Williamsburg in Bygone Days*. Richmond: The Dietz Press, 1973.

Stevens, William Oliver. *Old Williamsburg and Her Neighbors*. New York: Dodd, Mead, & Co., 1938.

Tyler, Lyon Gardiner. *Williamsburg, The Old Colonial Capital*. Richmond: Whittet & Shepperson, 1907.

Yetter, George Humphrey. *Williamsburg Before and After: The Rebirth of Virginia's Colonial Capital*. Williamsburg: The Colonial Williamsburg Foundation, 1988.

PHOTO CREDITS

Most images are from the author's personal collection. Several postcards were reproduced with the kind permission of the Curt Teich Postcard Archives of the Lake County Discovery Museum, 27277 Forest Preserve Drive, Wauconda, IL 60084. I thank Swem Library Special Collections for providing permission to include images from the papers of Carlton Casey, Williamsburg Historic Records Association collection, The College of William and Mary, on pages 22a, 26b, 31, 39a, 50, 54a, 58a, 74a, 78b, 82a, 87b, 101, 116b, 118, 119, 120b, and 123a. Steven Beauter provided images for pages 10a, 34, and 39b. H. Allen Curtis provided images for pages 36 and 123b. Thomas Hearn provided images for pages 19a and 94. Kurt Reisweber provided images for pages 16a, 18, 21b, 35, 61b, 68, and 143. Barry Zimmerman provided images for pages 2, 10b, 12a, 15b, 17b, 19b, 20a, 21a, 30a, 36/37a, 40b, 45b, 53a, 84b, 97a, 105a, 113a, 117a, and 117b.

Want to see more? Visit:http://williamsburgpostcards.com/

EASTERN STATE HOSPITAL INFIRMARY, C. 1907. Established in 1773 as the Public Hospital for Persons of Insane and Disordered Minds, Eastern State Hospital was the first mental hospital in America and continues to treat patients today. All of the buildings on the hospital's original campus were demolished. The infirmary was located in the center of the hospital campus, facing Francis Street. The main hospital building was destroyed by fire in 1885, but it was reconstructed in 1985. The property once occupied by ESH is now the location of the reconstructed hospital, the National Center of State Courts, a graduate student housing complex, the Marshall-Wythe School of Law, the DeWitt Wallace Decorative Arts Museum, and the McCormack-Nagelsen Tennis Center. Until recently, the James City County/Williamsburg Court and County Jail occupied part of the hospital site as well. ESH moved to the former Dunbar farm in 1970.